the ART of whimsical Lettering

JOANNE SHARPE

INTERWEAVE
interweave.com

EDITOR MICHELLE BREDESON
ASSOCIATE ART DIRECTOR JULIA BOYLES
DESIGN KARLA BAKER
PHOTOGRAPHER JOE COCA, except where otherwise noted
PRODUCTION KATHERINE JACKSON

Interweave
A division of F+W Media, Inc.
4868 Innovation Drive
Fort Collins, CO 80525
interweave.com

Manufactured in the USA by RR Donnelley

Library of Congress Cataloging-in-Publication Data

Sharpe, Joanne, 1959-
The art of whimsical lettering / Joanne Sharpe.
 pages cm
Includes index.
ISBN 978-1-62033-074-6 (pbk.)
ISBN 978-1-62033-073-9 (PDF)
1. Lettering. 2. Alphabets. I. Title.
NK3600.S529 2014
769.5--dc23
 2013028701

10 9 8 7 6 5

CONTENTS

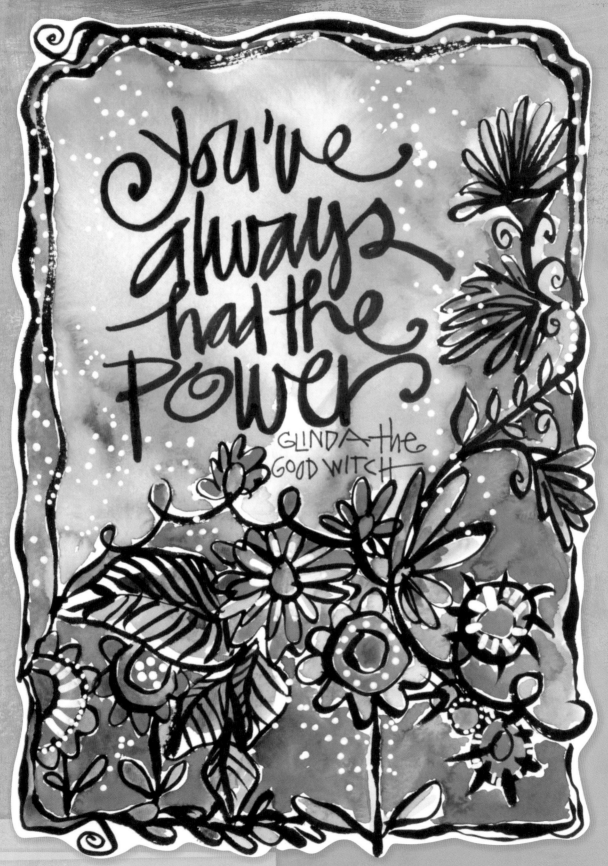

Watercolor with black waterproof pen lettering

INTRODUCTION
FINDING YOUR INNER FONT

Do you want to know the secret to creating whimsical lettering? As Glinda the Good Witch from *The Wizard of Oz* said, "You've always had the power." That power originated as a child when you were taught to write with pencil and paper.

Look at your own writing and you'll see that it has a distinct look; it shows your personality. Your handwriting is your identity; it is as much a part of who you are as your voice, your laugh, and your walk. It's how you show yourself to the world and how you respond to the universe in visual form. Combined with various creative techniques, your handwriting can be transformed and designed into a distinct style that is recognized as clearly your own.

When you begin to learn how to define your own lettering style, remember that this is a craft that takes time and practice. Think of this experience as your first piano lessons. You might not be playing a piece by Mozart immediately, but rather mastering the notes and movement of "Twinkle, Twinkle Little Star," taking baby steps on the journey to your personal perfection. When you're learning an instrument, it's important to practice every day. It's the same when learning hand lettering, in that you're only going to get really good at it by practicing the same letters over and over and over. Practice really does make perfect, and it's important that you embrace your own personal perfection. While you're making efforts to learn a lettering style, my best advice is to embrace your work as being "perfectly imperfect." Know that each brave attempt in any stage of a creative learning process is a perfect result in your learning curve.

Copic marker background and lettering
outlined with black Micron pen

PLAY.

practice

WRITE

REPEAT.

*THE SECRET TO ARTFUL LETTERING

Copic marker
background with Pan
Pastel accent colors and
black Pitt pen lettering

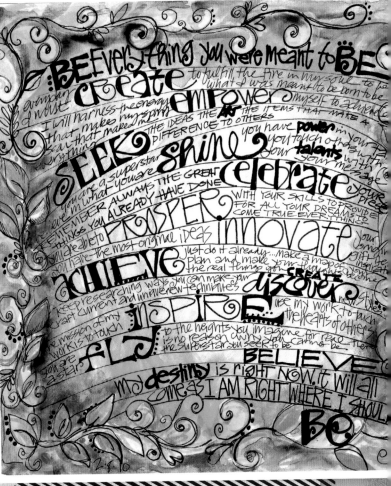

My philosophy on artful lettering is to empower you and give you confidence in your own handwriting. It's sometimes more frustrating to copy a style or alphabet because it never ends up looking like the sample you're trying to imitate. While copying and reproducing an art style is perfectly fine, it's important to dig deep in your own abilities and stretch yourself to develop your own creative identity. If your artwork is hanging on a wall, your style should be recognized from across a room, with an aesthetic that reflects who you are.

Your "inner font" emerges from a personal interpretation of alphabets and letters created with basic design elements, line variation, shape, size, and pattern. If you can write your name, you can letter with creative flair. Exploring new materials, stretching your existing supplies, and manipulating line, shape, and form are the key elements to the development of an artistic lettering style. Call on your own creativity to design a signature font and make your handwriting a personal expression.

Practice, patience, and openness to explore alphabets as an art form will define your signature style and authentic artful lettering. "Play, practice, write, repeat" is the mantra I teach my students learning about artful lettering.

In this book, I share the techniques and approaches I use consistently in my lettering art. Practice them, play with them, and then let your own inner font emerge to make the art you have always had the power to create.

joanne sharpe

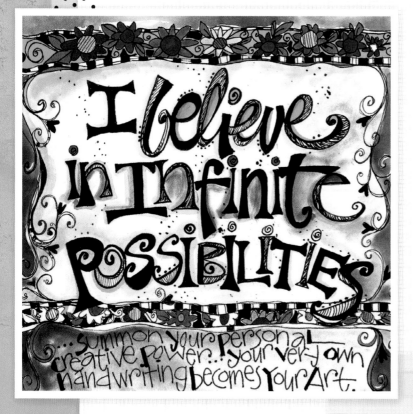

Copic marker and Pan Pastel background with black Micron pen lettering

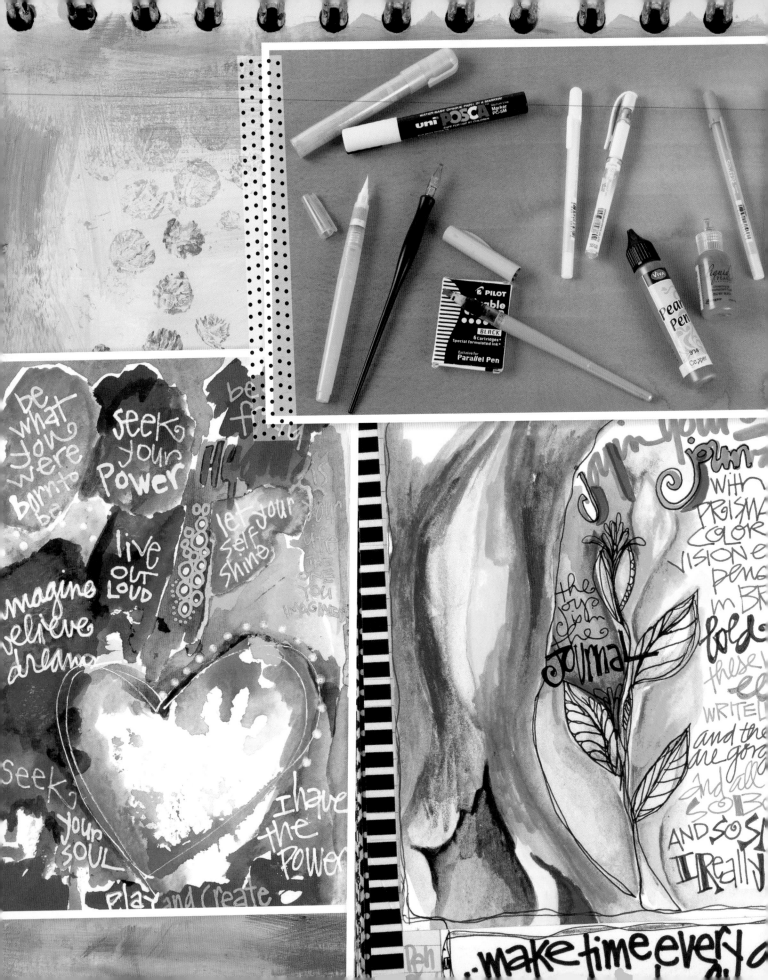

the Whimsical Lettering Studio

What are the best pens, inks, markers, papers, journals, and substrates for lettering? I'll share my favorites with you and show you how they contribute to the look and style of my lettering art. Of course I'm sure you can dig into your own stash to find comparable items. There are so many supplies to choose from, but the magic of lettering really comes from deep inside you.

TOOLS OF THE TRADE

Let's be honest, pens are like shoes. You can never have enough pens, or shoes! One really never needs another pen or more shoes, but when the perfect specimen appears, one must indulge.

When lettering is used as creative expression, it's logical to use a variety of pens that create specific effects and letter looks. Be in constant pursuit of the "perfect pen." I might suggest a certain pen that I love, but you have to decide for yourself what you're most comfortable with and what works for you and your budget. There are hundreds of pens and writing tools to choose from, each with a specific promise of performance. Different effects are achieved with specific tools.

WATERPROOF PENS

An absolute necessity and the most basic lettering tool is the waterproof pen. With a waterproof pen, you can letter, doodle, draw, and add paints and water media without worrying about the ink bleeding. There are many styles and many brands, and any are fine as long as they don't bleed or smear when water media is added near them. Microns, Pitt, and Uniball Vision pens are waterproof, permanent pens and are ideal for fine writing and lettering. They come in various colors, but black pens in particular are my favorites for lettering and adding doodled embellishments. I always have an assortment of black pens at my fingertips that will function perfectly for specific techniques. It's important to build a personal pen collection that includes a variety of tip styles, such as broad, fine, chisel, calligraphy, brush, etc., so you always have the perfect pen to achieve a certain letter look.

MAGICAL MARKERS

There are dozens of types of markers in hundreds of colors and styles for writing and lettering techniques. There are alcohol ink markers that are permanent and waterproof, such as Copic, Prismacolor, Sharpie, and Spectrum Noir. Dye-based Tombow markers create intense watercolor effects. These markers have nylon or felt tips in bullet, chisel, and brush styles and are great for creating assorted thicknesses and letter variations.

FOUNTAIN PENS

Get reacquainted with the beauty of an "old school" fountain pen with assorted waterproof or traditional

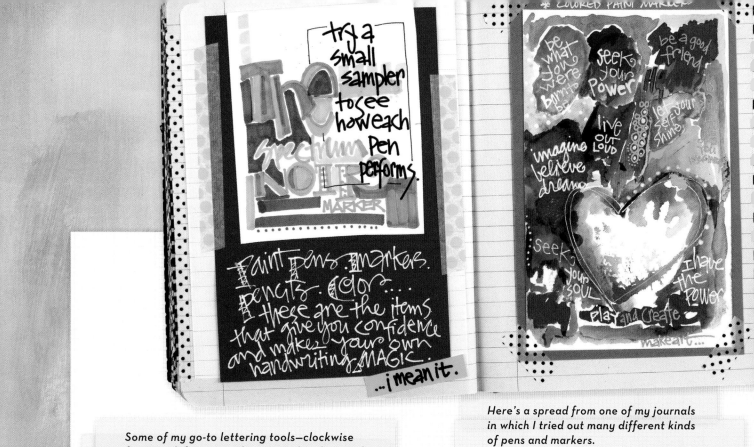

Some of my go-to lettering tools—clockwise from top left: watercolor paints, brushes, and lettering inks; waterproof pens; fountain pens, and markers

Here's a spread from one of my journals in which I tried out many different kinds of pens and markers.

Photo by Ann Swanson

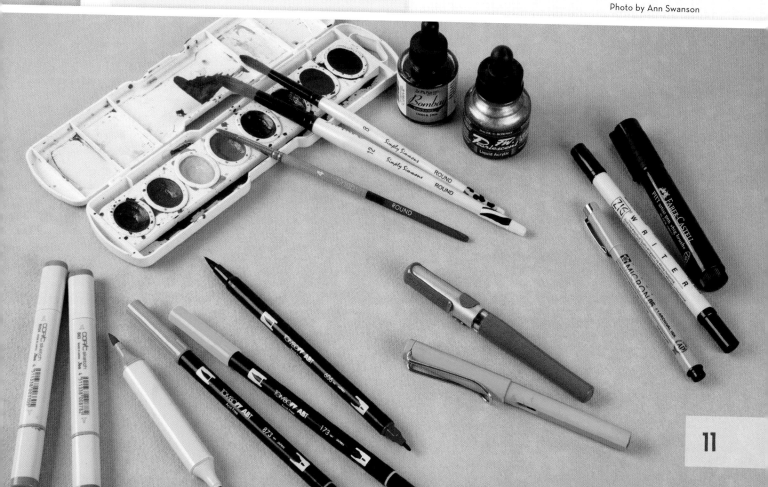

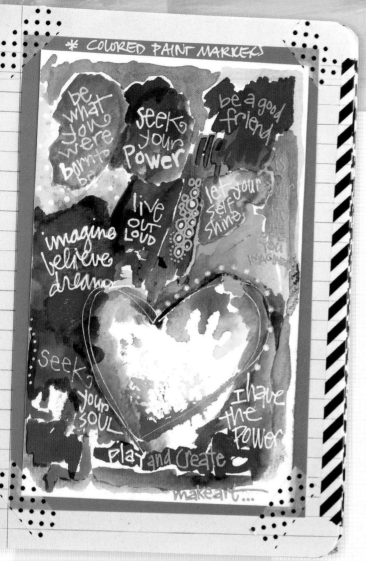

For this journal page, I experimented with white gel pens, paint markers, and watercolors.

color or acrylic paints, the soft bristles make it easy to create interesting letterforms. Depending on the size of the letters I'm creating, I prefer size #4, #8, #10, and #12 watercolor brushes. The best assortment of these brushes is usually found in a fine-art store.

CALLIGRAPHY PENS

Created for traditional italic and decorative writing, calligraphy pens have metal nibs that are dipped into India and acrylic inks. This book doesn't go into detail on calligraphy, so if this traditional style of lettering interests you, perhaps a formal class or instruction would be beneficial. But by all means, play with them to explore some of the techniques.

PARALLEL PENS AND INK

This is a contemporary calligraphy pen with a crisp metal nib. It has a flat stainless steel tip that allows ink to flow through the tip to make thick and thin calligraphic pen strokes. The ink for these pens comes in cartridges with refills in a variety of

inks. A fountain pen is economical and refillable, so your favorite lettering look is always consistently available. There is something so pure and wonderful about watching wet, fresh ink glide across paper creating beautiful letters.

PAINTBRUSHES, PAINT, AND INKS

Watercolor brushes in various sizes are an excellent choice for hand lettering. Loaded with inks or water-

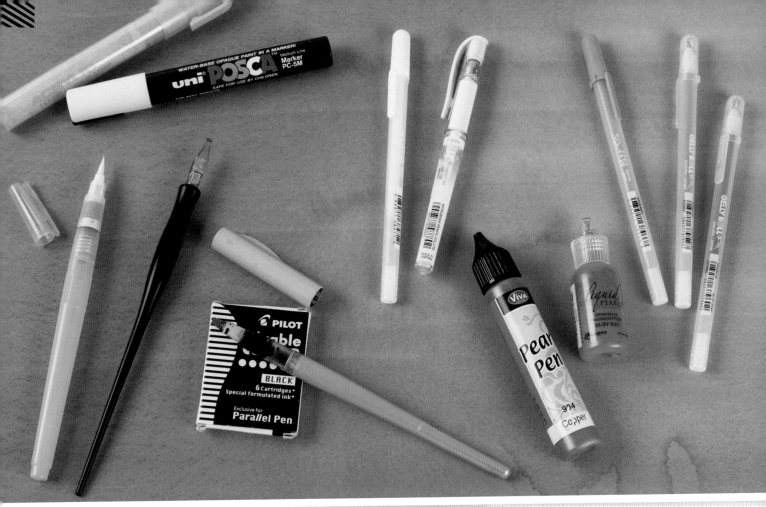

Photo by Ann Swanson

More fun lettering tools to add to your stash—clockwise from top left: paint markers, white pens, glaze/glitter pens, dimensional paints, parallel pen and ink cartridges, calligraphy pen with nib, water brush.

colors. My personal preference, and the most popular brand of parallel pen, is the Pilot Parallel Pen, which comes with pre-loaded cartridges.

WHITE PENS
Make a dramatic, bold statement with white ink on dark paper. I like Signo UM-153, Sakura gel, and Souffle white pens. Write slowly with this type of pen to allow for a consistent, smooth ink flow onto your paper surface. These pens work well on most dark papers, as well as over inks, watercolor, and acrylic paint. Words, letters, and doodles pop right off the page.

GLAZE/GLITTER PENS
Add sparkle and shine to letters with Sakura or Signo gel, glaze, metallic, and glitter pens. These pens have free-flowing ink that floats over paper with a velvet sheen.

PAINT PENS

Sharpie and Montana make pens you can fill with acrylic paint. They create thick, bold lettering and are waterproof when dry.

BRUSH PENS

There are many brush marker pens available that mimic a paintbrush in a marker form. They have nylon or polyester tips and are very convenient as the ink or paint comes already loaded in the brush.

WATER BRUSH

A water brush has a reservoir you can fill with water so you don't have to dip your brush in a separate container. Niji and Sakura make water brushes with assorted tip sizes. Write with a water brush dipped in watercolor ink or paints for a casual, loose print or script style.

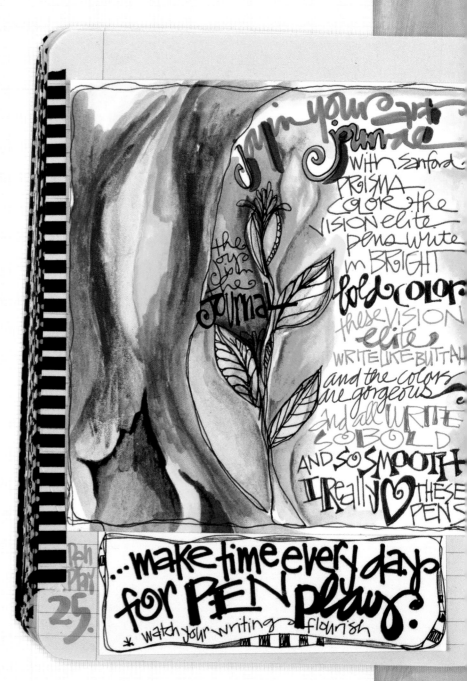

DIMENSIONAL PAINT

Create colorful raised letters with the many brands of dimensional paints on the market. They are packaged in plastic bottles with pointed applicator tips that make it easy to letter. You might see them sold as "T-shirt" paints or "puffy paints."

GLUE STICK AND CRAFT FOIL

Write out letters and words with a glue stick and then adhere shiny craft foil to the surface and pull it off while it's still tacky. This creates a freehand metallic look for letters.

GESSO

Gesso is an opaque acrylic paint primer with many uses. Get an interesting effect by applying white or black gesso to a surface with a paintbrush. Write into the wet gesso with a pointed tip such as the end of a paintbrush and let it dry. This creates an interesting textured and dimensional effect.

GEL MEDIUMS

Create a resist under water-based paints and inks by lettering with a paintbrush dipped in gel medium. Gel medium is a versatile acrylic product that is used in mixed-media art as a glaze, collage glue, paint extender, and texture paste. When dry it is crystal clear. If you paint over the dried gel medium with watercolor or acrylic paint it acts as a resist. The raised lettering made with the gel medium will "pop" under the painted surface.

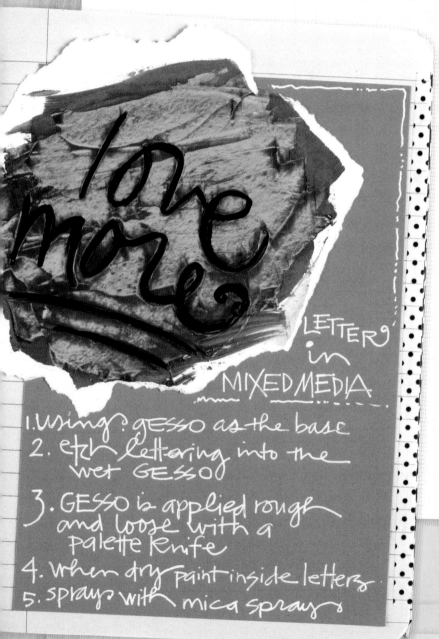

love more

LETTERs in MIXED MEDIA

1. Using gesso as the base
2. etch lettering into the wet GESSO
3. GESSO is applied rough and loose with a palette knife
4. When dry paint inside letters
5. sprays with mica sprays

Writing in gesso creates a richly textured effect.

PAPER AND OTHER SURFACES

"What is the best paper to use for lettering?" I am asked this question constantly by my students. First, determine the purpose of your lettering project.

Are you journaling your thoughts and ideas as a personal artistic expression no one else will see? In this case, less expensive journals and papers will probably be fine. Are you illustrating favorite words and quotes as a finished art book or keepsake? Are you making art to frame and hang on the wall? Is it a gift? Are you selling your artwork? For these purposes, you might consider a good-quality paper, journal, or canvas.

Decide why you're going to create lettering art. Are you exploring different styles to create your own signature look with pens, pencils, and markers? Are you experimenting with technique and exploring new styles requiring a lot of practice? Are you looking to paint, collage, sketch, and letter in just one art journal? Are you collecting ideas and inspirations? If the art is for your personal discovery, you can educate yourself

with various qualities and price points of papers and journals.

Regardless of what your creative process demands, it's a good idea to explore a variety of materials to meet your needs. Become familiar with student-quality papers and journals as well as professional grades that will be more costly. It really is your personal preference as to how much you want to invest in the materials for your projects, whether they are personal or professional. It's up to you to decide what fits into your lifestyle and budget.

ART JOURNALS

There are many brands, paper types, and surface textures to choose from. A 90 lb or 140 lb smooth Bristol paper or a watercolor journal is my choice for mixed-media lettering. When working in a book-type journal, you want to make sure that it's going to be comfortable. Some books have spiral bindings that can

Strathmore Visual Journal

be a little awkward on your hand. There are others that are bound with signatures that don't always open completely flat for working, so you might want to take that into consideration. In a journal, I always make sure the binding opens flat so I can work across the entire two-page spread. My personal favorites are all of the varieties of Strathmore Visual Journals and the Moleskine and Hand Book brand journals.

GRAPH PAPER

To get comfortable and confident with letter spacing, height, and design, keep piles or pads of graph paper handy. It's a staple in the exploration of lettering and fairly inexpensive to use as practice paper. The lines will help you to fully grasp the dimensions of letterforms and explore various composition and layouts.

TRACING PAPER

A helpful practice is to trace by hand and duplicate actual letterforms on tracing paper to understand the feel and movement of letters. Find inspiration for your own font creations by copying the characteristics of printed letters.

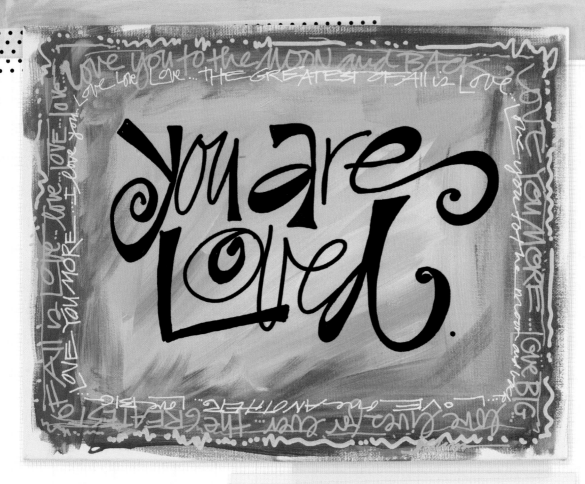

Canvas makes an excellent surface for lettering projects.

CANVAS

Pre-stretched canvases or canvas panels are interesting surfaces for painting in acrylic paints and textures and decorating with verses, quotes, and artwork. Canvases range in price from inexpensive to whatever your budget will bear. One of the techniques I enjoy is filling the surface with organic lines, whimsical shapes, and vibrant acrylic paint color, then writing an inspirational message with a water-resistant marker that works on a nonporous surface.

WATERCOLOR PAPER

Much of my inspirational art and illustration is done on watercolor paper or in a watercolor-paper journal. The light, sheer, vibrant colors of watercolor paint make the most beautiful background surface for washes and patterns for lettering art. I reach for watercolor most of the time, so I have a variety of hot press (a smooth surface—just think of the watercolor paper as being "ironed" smooth and flat) and cold-press papers (textured surface—think of being cold with

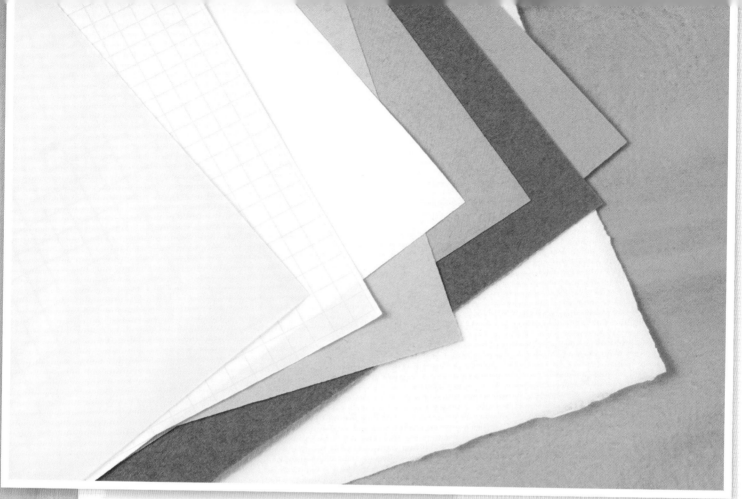

A few of my favorite surfaces for lettering—from left to right: tracing paper, graph paper, printing paper, assorted sheets of cardstock, watercolor paper.

"goose bumps"). I get many interesting effects on both types of paper, and they both react differently when inked or lettered with pens and markers.

PRINTING PAPER

If you take my "Play, Practice, Write, Repeat" mantra to heart, you will use reams and reams of inexpensive printer or copier paper for practice. Write and write until you love your efforts and keep the good papers pasted in a lettering journal. You can create wonderful collage elements by cutting or tearing up your lettering pages and adding them to other artwork as design elements and paper embellishments.

CARDSTOCK

Heavy paper is perfect for marker or paint techniques that require more saturation of inks or layers. Many brands of cardstock in white, buff, and assorted colors are easily accessible at craft and art stores, as well as office supply stores. Again, practice pieces done on these papers can be nicely incorporated into other artwork or collaged journal pages. Always keep your favorites to use at another time.

get in shape with your WORDS

This style is to help with layout and compositions

it's very FUN to write different...

These shapes are to EXPLORE

the LETTER box

fill each box or shape to the BRIM

each box shows a NEW style of WRITING

try all kinds of writings & all kinds of words contained in a SHAPE

use all of your FANCY Pens

letterforms so they the page

A B
W E
G H I
X Y

COLOR WITH MA

in layers

then

ld your

VORDS

oing

from

he lightest

color

to

black

ANY LATTERS FOR WORDS

his gives me ideas

Kay

words
OVER
OUR
nding
OUR
MESSAGE

A B C D E F G H I J K L M
N O P Q R S T U V W
X Y Z a b c d e f g
k l m z a b c d e f g i r s t u
x y z abcdefghijklmnopqrstu

" Oh My Wor
ARTFUL
LETTERING

letter
ART
alpha
bet
upper
case
lower

LETTE
Lou
INSPIRA

Letter Love Inspiration Journal

One of my greatest personal resources is what I call my Letter Love Inspiration Journal. This is a very casual journal, filled with ideas, messy practice pieces, scribbles, notes, fonts, and samples showcasing all things I love about lettering. In this chapter, you can take a peek inside my journal and discover some prompts and inspiration for creating your own lettering journal.

THE JOYS OF JOURNALING

My journal is really a place to play, with no judgments or critiques. It's my personal collection of practice letters, scribbled ideas, and thoughts about what inspires me about how I create my own distinct style of lettering.

This is really an important part of my process for creating new designs and direction in my lettering. To me, lettering is my art, and I constantly have to grow with my art. As an artist, I am always seeking inspiration, ideas, and influence from my surroundings, whether in my own imagination, my daily life, or travels.

As you become more aware and curious about artful lettering, identify the elements of letterforms that inspire you to pursue these ideas with creative wings. Be brave and try new movements with your hand and arm as you write, stretching and exploring which direction feels most natural to you. Always be on the lookout for interesting images, lettering styles, fonts, creative layouts, and designs. Gather items from the Internet, books, magazines, junk mail, brochures, travel memorabilia, etc. Fill your journal with bits of lettering treasures, clippings, practice samples, and ideas.

Use small journals in a landscape format to experiment with word layouts and compositions.

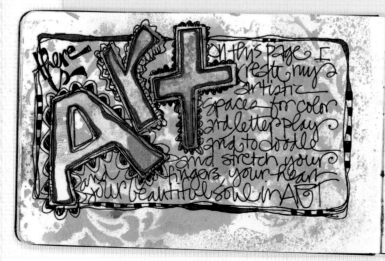

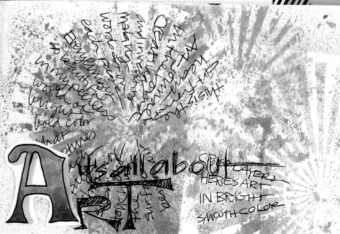

MAKING YOUR OWN
LETTER LOVE JOURNAL

Make your own lettering inspiration journal using a simple, inexpensive composition book.

Glue every other page together with glue stick to make the pages stronger. Use assorted pens and materials to decorate, design, and color pages with lettering, words, quotes, and ideas. Record every creative whim on the pages until it's overstuffed with ideas and inspiration. Save your piles of paper doodles and scribbles and paste them into your book.

As you use this space, experiment and develop your own personal style using images and designs that speak to you. Don't worry about how the pages look; just fill them up. This journal is a place for experimentation and collecting ideas that make you swoon.

TIP

You can reinforce the edges of the pages with fun, decorative washi tape, which is a low-adhesive colorful masking tape found in art and craft stores.

Using assorted markers and pens, decorate the cover of your Letter Love journal in your own personal lettering style.

LOVE LETTER INSPIRATIONS

In the pages that follow, I share excerpts from my own personal journal along with prompts to guide you in filling your own Letter Love Inspiration Journal.

Grab a fresh blank notebook or journal and all your favorite journaling supplies in your personal art stash. Begin your lettering adventure by filling pages with these playful activities. You'll end up with at least twenty-five pages instantly!

Remember, your journal is a safe, fun place to experiment with ideas for lettering. The pages of ideas and practice work in this journal are not meant to be perfect. This is how you will learn, how you know what works.

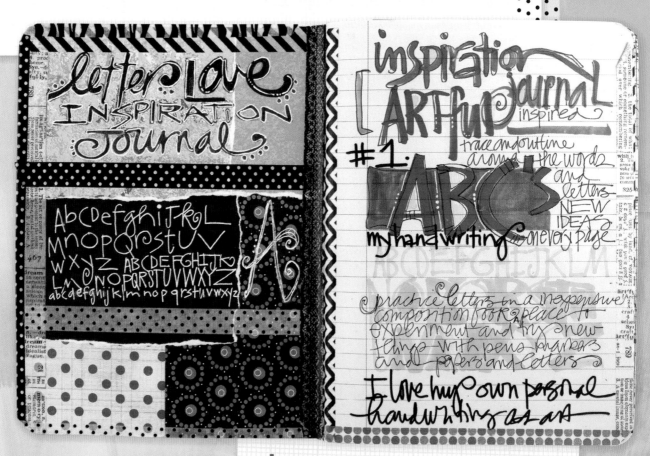

1 Play around with your own handwriting, creating words and entire alphabets with all the pens or markers on your desk.

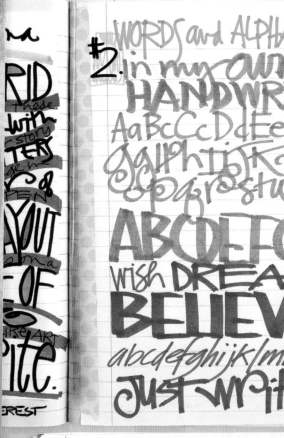

2. #5 WORDS and ALPHAS in my own HANDWRITING
AaBbCcDdEeFf GgHhIiJjKkLlMm NnOoPpQqRrSsTtUuVvWwXyZ
ABCDEFGHI
wish DREAM
BELIEVE
abcdefghijklmnop
JUST write!

2 Write several pages of words and alphabets in all capital letters, upper and lower case, large, small, tall, wide, skinny, and fat. Don't judge, just write pages and pages, sampling your letter flow and creativity.

3 Doodle letters with colored markers. Add colorful patterns, swirls, stripes, lines, and dots to embellish the letters.

4 Look through old magazines and other printed materials to find words and phrases in assorted typefaces and sizes that you find interesting. Cut them out and paste them in your journal. Become a pasting pack rat with anything that you hand letter and make sure it ends up in your journal.

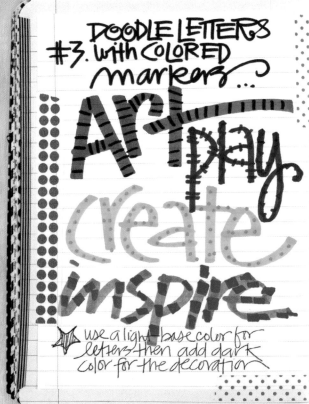

#3. DOODLE LETTERS with COLORED markers...
ART play
create
inspire
use a light base color for letters then add dark color for the decoration

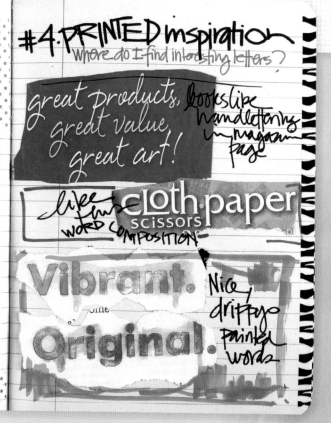

#4. PRINTED inspiration
where do I find interesting letters?
great products, great value, great art!
looks like handlettering in magazine page
like this word composition
CLOTH paper
scissors
Vibrant.
Original.
Nice, drippy painted words

my inspiration

#5. COLOR WITH MARKER
LAYERS in layers then add your WORDS going from the lightest color to black
MANY LAYERS FOR WORDS

layer words over your finding your MESSAGE

* this gives me ideas

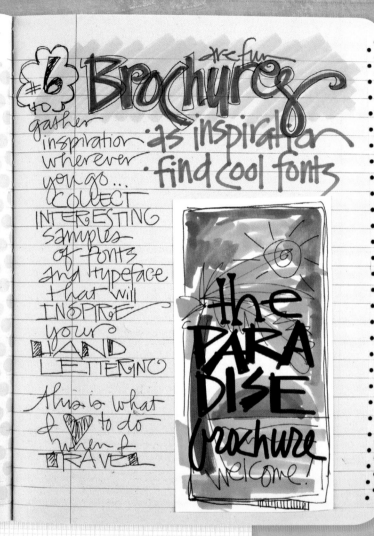

#6 Brochures are fun
gather inspiration wherever you go... COLLECT INTERESTING samples of fonts and typeface that will INSPIRE your HAND LETTERING

This is what I ♥ to do when I TRAVEL

as inspiration
find cool fonts

the PARA DISE brochure welcome!

5 Using assorted markers, color in layers and add words on top of each layer.

6 Collect brochures or magazine clippings with interesting letter placement and unusual compositions and layouts of text to inspire new ideas and direction for your lettering projects.

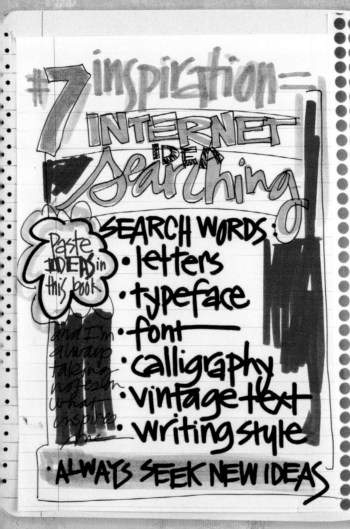

#7 inspiration =
INTERNET
IDEA
Searching

Paste IDEAS in this book

and I'm always taking notes on what inspires me.

SEARCH WORDS:
- letters
- typeface
- font
- calligraphy
- vintage text
- writing style
- ALWAYS SEEK NEW IDEAS

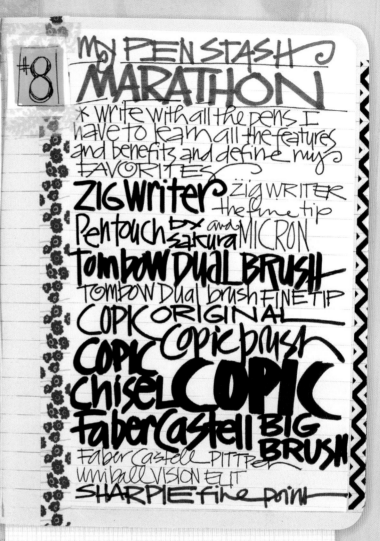

#8 MY PEN STASH MARATHON

* write with all the pens I have to learn all the features and benefits and define my FAVORITES

ZIG writer Zig WRITER the fine tip

Pen touch by Sakura MICRON

Tombow DUAL BRUSH

TOMBOW Dual brush FINE TIP

COPIC ORIGINAL

COPIC Copic brush

Chisel COPIC

FaberCastell BIG BRUSH

Faber Castell PITT Pen

Uni ball VISION ELIT

SHARPIE fine point

7 Do an Internet search for topics relative to lettering, such as lettering, fonts, typeface, handwriting, letters, alphabets, calligraphy, etc. Use your colorful pens and markers to jot down notes and inspirations in your journal as you come across ideas that "speak" to you.

8 Get out every single pen you own and write what is unique to each brand and style. Fill as many pages as you need to make it through your entire pen "stash"!

9 Collect samples of interesting maps and old book pages and glue them into your journal. Use them as backgrounds for your lettering.

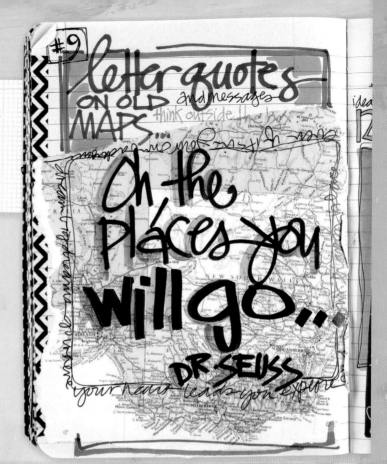

letter quotes
ON OLD and messages
MAPS... think outside the box

Oh the Places you will go...

DR SEUSS

your heart leads you explore

10 Purchase some new pens you've never used before. Start to define your own alphabets and lettering using the features of the new materials.

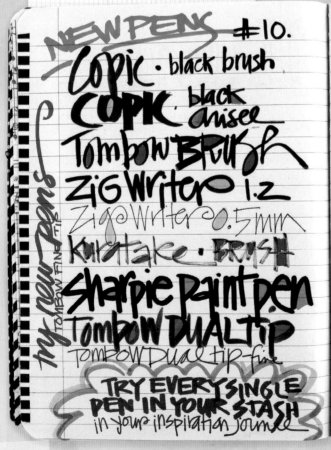

NEW PENS #10.
Copic · black brush
COPIC · black chisel
Tombow BRUSH
ZiG Writer 1.2
Zig Writer 0.5mm
Kuretake · BRUSH
Sharpie Paint pen
Tombow DUALTip
TOMBOW Dual tip fine
TRY EVERY SINGLE PEN IN YOUR STASH
in your inspiration journal

my new pens TOMBOW FINE TIP

just write your ABC's over and over again...
PLAY in this BOOK... WITH NEW TOOLS... new pens to you... It's your hand and your ALPHABET...
AND THEN WHAT DO YOU LOVE...?
in the letters...

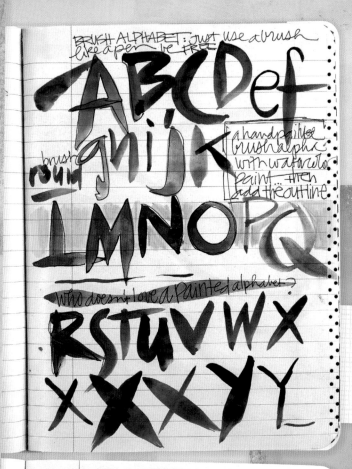

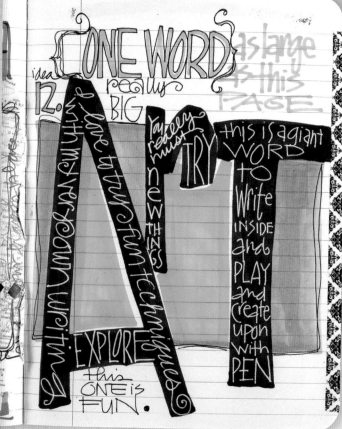

11 Handpaint words in your journal
pages with acrylic or watercolor
inks and paint. Let the paintbrush
be your pen tool.

12 Play with scale. Write one word the
full size of the page and surround it
with a block of color. Add journaling
or other text over the large word in
a fine pen.

13 Experience the drama of writing on black papers with white, gel, and metallic pens. Cut or tear small pieces of black cardstock paper and paste them into your journal or paint your pages with black gesso.

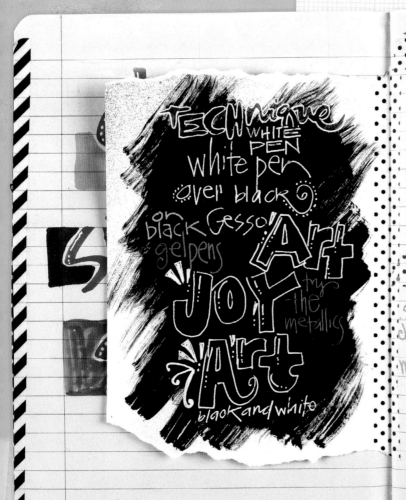

TECHnique
WHITE PEN
white pen
over black
on
black Gesso
gelpens
Art
JOY
try the metallics
Art
black and white

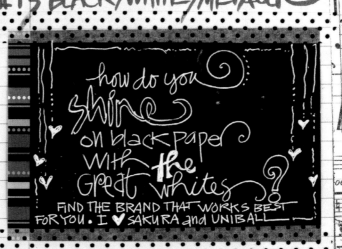

#13 BLACK/WHITE/METALLIC

how do you
shine
on black paper
with the
Great whites ?
FIND THE BRAND THAT WORKS BEST
FOR YOU. I ♥ SAKURA and UNIBALL

sakura
jelly
ROLL
metallic

SPARKLE WINK OF STELLA
SPARKLE WINK OF STELLA
SPARKLE wink of stella
SPARKLE wink of stella vs
SPARKLE wink of stella
SHIMMER shine and you SPARKLE

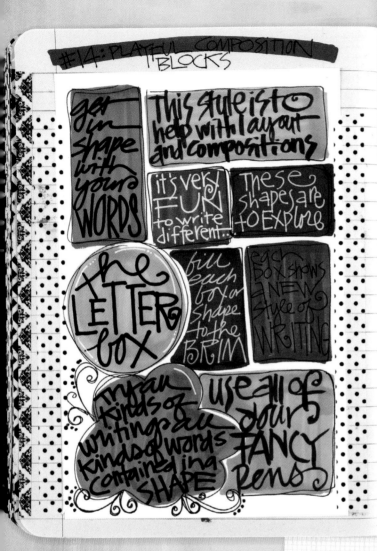

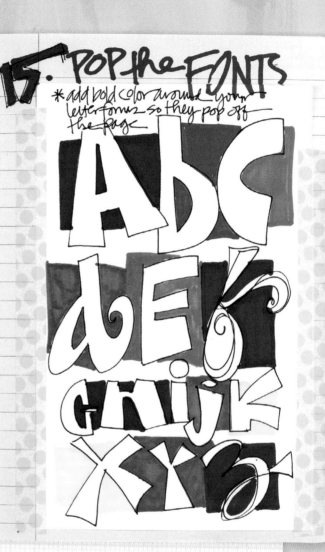

14 Draw a composition of playful journaling boxes in various sizes. Fill each box individually with your favorite quotes or writing.

15 "Negative space" refers to the empty area around written letters or words (or other shapes). Color in only the negative space around letters or words to make them "pop" off the page.

16 Test your markers and pens to see if they're waterproof by writing something with each pen on a page and then run a wet paintbrush over the lettering. It's better to do this in your journal than on a piece of finished artwork!

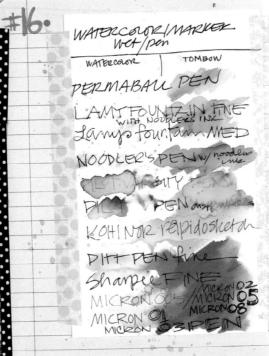

WATERCOLOR/MARKER wet/pen

WATERCOLOR	TOMBOW
PERMABALL PEN	
LAMY FOUNTAIN FINE with NOODLER'S INK	
Lamy's fountain MED	
NOODLER'S PEN w/ noodlers ink	
PILOT FUNCALLY PEN	
PILOT V PEN	
KOH NOOR rapidosketch	
DITT PEN fine	
Sharpie FINE	
MICRON 005	MICRON 02 / MICRON 05
MICRON 01	MICRON 08
MICRON 03 PEN	

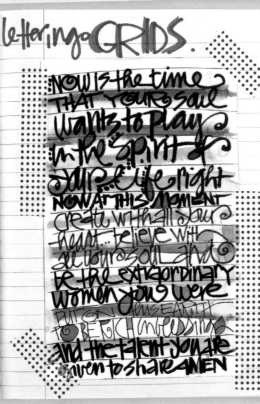

ARE YOU WATERPROOF?

TOMBOW Are these pens water proof?

Memento markers

TOMBOW
KOI color brush
DISTRESS markers
ZIG-WRITER Pigment
FABER-CASTELL big brush

nice colors for writing not great for water coloring it but a nice line tip for journaling

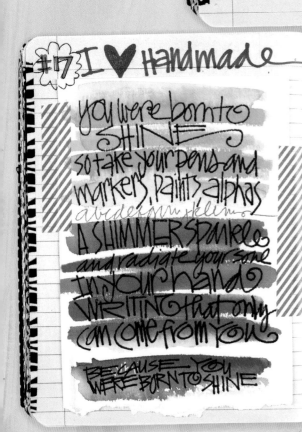

#17 I ♥ handmade lettering GRIDS.

you were born to SHINE so take your pens and markers, paints alphas abcdefghijklmnop A SHIMMER SPARKLE and radiate your shine in your handwriting that only can come from you BECAUSE YOU WERE BORN TO SHINE

NOW IS THE time THAT YOUR SOUL wants to play in the spirit of your life right NOW AT THIS MOMENT create with all your heart...believe with all your soul and be the extraordinary women you were put on this earth to be rich in blessings and the talent you are given to share AMEN

17 With watercolor paints or markers, create thick lines to act as grids. Hand letter inside the gridlines. Try different intensities of paints and markers for various effects.

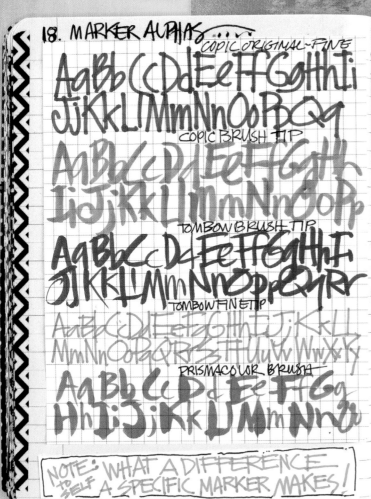

18. MARKER ALPHAS

COPIC ORIGINAL~FINE

COPIC BRUSH TIP

TOMBOW BRUSH TIP

TOMBOW FINE TIP

PRISMACOLOR BRUSH

NOTE TO SELF: WHAT A DIFFERENCE A SPECIFIC MARKER MAKES!

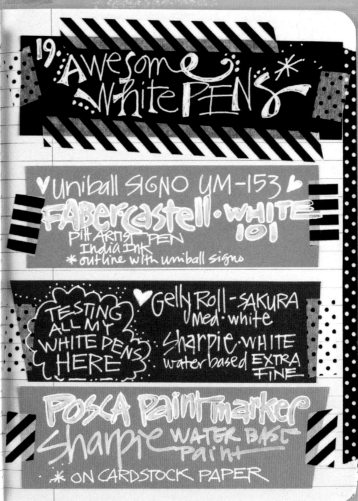

19 Awesome white PENS

♥ Uniball SIGNO UM-153 ♥
FABERCASTELL·WHITE 101
PITT ARTIST PEN
India Ink
* outline with uniball signo

TESTING ALL MY WHITE PENS HERE

♥ Gelly Roll ~ SAKURA
Med · white
Sharpie · WHITE
waterbased EXTRA FINE

POSCA Paint marker
Sharpie WATER BASE Paint
* ON CARDSTOCK PAPER

18 Paste graph paper in your journal and write out assorted alphabets with several types of markers. Use the graph paper squares and grids to explore the height and spacing of letters.

19 Letter with white pens on bright-colored cardstock and paste it into the journal.

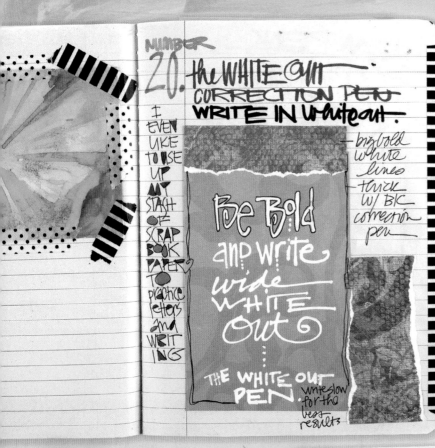

NUMBER
20. the WHITE OUT
CORRECTION PEN
WRITE IN whiteout.

I EVEN LIKE TO USE UP MY STASH OF SCRAP BOOK PAPER TO practice letters and WRITING

Be Bold and write wide WHITE Out

THE WHITE OUT PEN

- big bold white lines thick w/ BIC correction pen

write slow for the best results

20 Use a white correction pen to letter a quote in thick, bold white lines over a brightly colored marker background or scraps of colored paper.

21 Make "alphabet soup" with assorted marker tips. Create an interesting composition with all the letters of the alphabet, varying the height, thickness, and angles of the letters.

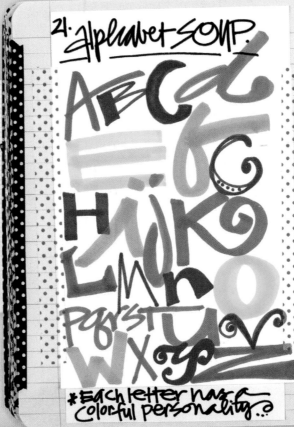

21. alphabet SOUP.

ABCd
EFG
HIJK
LMnO
PQRST UV
WXYZ

#Each letter has a colorful personality.

#23

beautiful
...tea
Ar
...create an
are pe
LETT
...then
the PO
AWESOME P
are

22 Colorfully illustrate a phrase or quote with markers on upcycled book-paper pages.

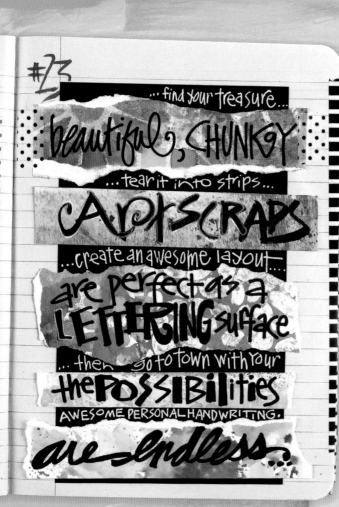

#23

...find your treasure...

beautiful, CHUNKY

...tear it into strips...

ART SCRAPS

...create an awesome layout...

are perfect as a LETTERING surface

...then go to town with your

the POSSIBILITIES

AWESOME PERSONAL HANDWRITING.

are endless...

23 Write words on cut-up strips of painted paper scraps and paste them into your journal in an interesting arrangement.

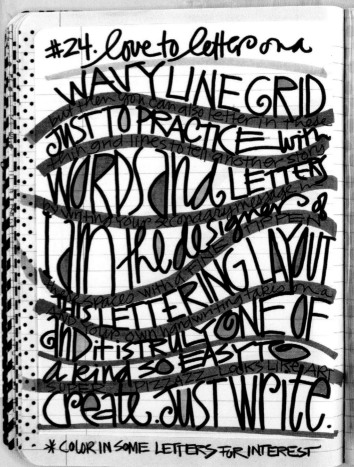

#24. love to letter on a WAVY LINE GRID but then you can also letter in these grid lines to tell another story JUST TO PRACTICE with WORDS and LETTERS by writing your secondary message in between I am the designer of THIS LETTERING LAYOUT the spaces with a FINE TIP PEN and your own handwriting takes on a and it is truly ONE OF a kind SO EASY TO SUPER PIZZAZZ looks like ART create. just write.

* COLOR IN SOME LETTERS FOR INTEREST

24 Create a wavy lined grid and write along the curves, varying the heights of your letters to fill the spaces.

25 Make time for creative "pen play" in your inspiration journal every day. Try different lettering styles with different pens, assorted papers, new colors, and collected materials. Experiment constantly and use the composition book as a "safe zone" for making lettering art with no rules and no judgment. This is the journal where anything goes!

Keep going! Once you work your way through these twenty-five prompts, try some of your favorites again. Create additional pages in your journal using your newly acquired whimsical lettering skills.

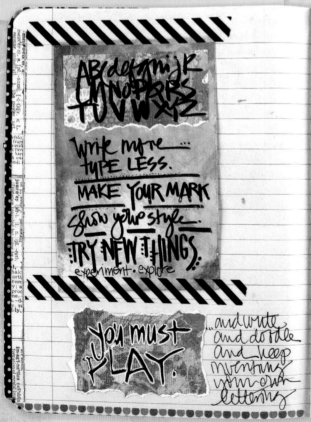

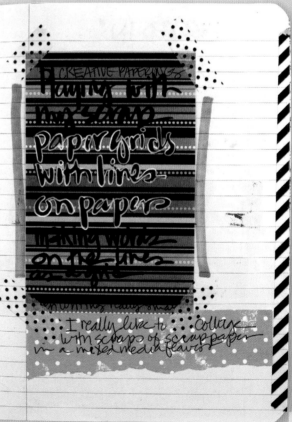

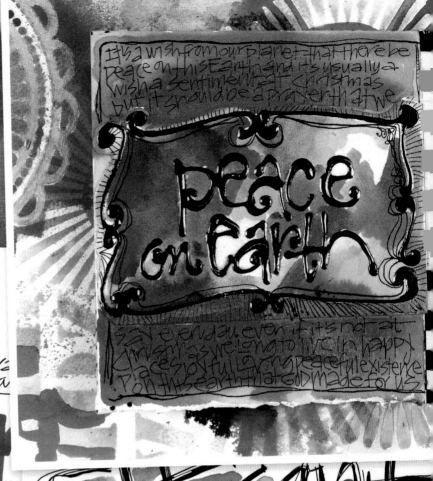

It's a wish from our planet that there be peace on this earth and its usually a wish a sentiment at Christmas but it should be a prayer that we

peace on earth

say everyday even if it's not at Christmas as well as to live in happy places joyful loving peaceful existence on this earth that GOD made for us

JOY.
decorate detail

Wonder
squares/beads

passion
daggers/dots

PURPOSE
white highlights/dots

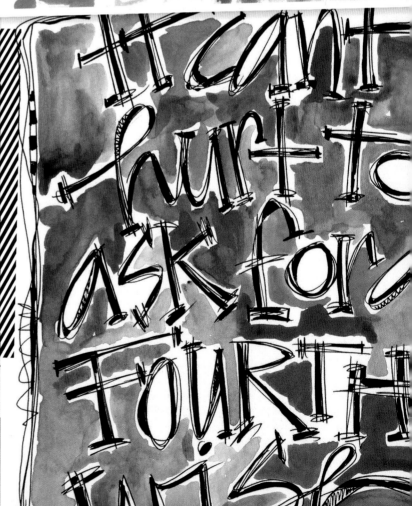

It can't hurt to ask for fourth wish

Artful Letter Plays

It's essential to try new things and have fun with the creative process. In this chapter, you'll experiment with pens, markers, paints, and other materials to learn how to transform your own handwriting into art. I'll share the techniques I use consistently in my own personal artwork. These are the fundamentals of whimsical lettering.

HANDWRITING AS ART

These days, we are consumed by type and text from computers and other electronic devices that just pump out cold, impersonal characters. Lettering and handwriting is a lost art in a technological age. I've heard recently of school districts considering the elimination of handwriting education for young children, since they are using more electronic devices in classrooms. What a disaster that would be! Can you imagine?

Handwriting is a part of our expression as human beings and is unique to who we are. As children, we learned to write with specific rules and instruction. But as individuals, we soon developed our own writing style that is unique to our own personality. No two people have the exact same handwriting. So why not take the fundamentals of your individual hand and infuse some art and design principles to create whimsical lettering?

As a product of Catholic schools, I was strictly taught by disciplined nuns who demanded perfection and conformity. I can still picture the cursive alphabet cards posted in the skinny cork borders above the chalkboard. (Oh, yes, dusty, messy chalkboards, remember when we had those in school?) As an adult lettering artist, I find great value in those principles and rules, as I was taught to appreciate the beauty of every perfect line and distinctive curve that formed each individual letter. It's by mastering the basics that I was able to veer off the "conformity course" and create my own signature hand lettering.

OK. Here's a confession. My own personal handwriting is not that great. It's all over the place and sometimes I can't even read it myself. I misspell words, skip words in a sentence and sometimes I even forget letters in a word!

But when I'm doing my "lettering", I slow down intentionally, get in the "zone" with all my supplies and my writing becomes my art.

SIGNATURE Joanne Sharpe

Even professional lettering artists don't always have the most perfect handwriting!

EVERYDAY WRITING

If you're going to play with, learn, and explore new lettering techniques, you must start with your very own personal printing and cursive writing. Allow it to evolve into an artful expression. Here are a few tips to get you on the path to creating whimsical lettering every day.

Shake your hands and arms and loosen up before you place a writing utensil in your hand.

Let go of your inhibitions and fear of failure. This isn't formal calligraphy. This is whimsical lettering—creative expressions and exploration of letterforms—using the writing you have harbored and evolved since childhood.

Forget about the excuse, "But I hate my own handwriting." Put that thought right out of your mind. Be confident with your own skills and that you have the power to make wonderful works of inspirational and meaningful art from your own handwriting. You can do this!

Try using unfamiliar supplies, such as brand-new pens, pencils, markers, paintbrushes, etc.

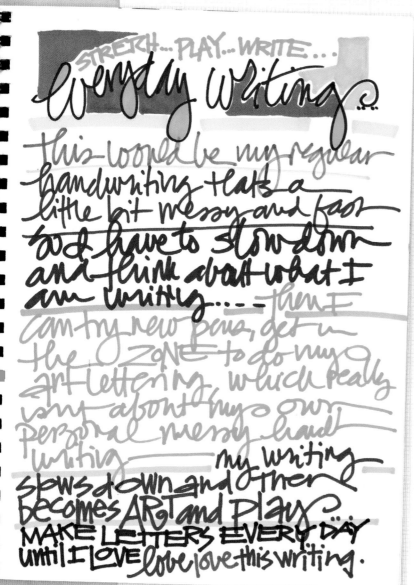

Step out of your comfort zone and experiment with altering your handwriting, leaning your letters to the left if you normally lean right, and vice versa.

Get into a "pen Zen" or "pen trance" and just write! Pick a favorite pen and write in a designated practice journal for 15 or 20 minutes, in cursive or print, as a warm-up exercise before you begin your lettering art. Write words continuously without picking the pen up off the page. Letter your thoughts without stopping.

Treat yourself to a fountain pen and practice the art of handwriting every day. Fountain pens are not disposable, and you actually have to fill them with real ink. That makes fountain pens hip, happening, and very green.

Write something every day. There is great pleasure to be found in the art of handwriting. In the age of keyboards, touch pads, and technology, it feels good to have a real pen in your hand, making real marks and messages, watching wet ink dry, and making meaningful marks on fresh, crisp papers.

Identify what you don't like about your writing and explore ways to alter the characteristics that you don't like.

Practice, practice, practice! Then practice some more.

ARTFUL BASICS

There are several techniques I call my "artful basics," which I incorporate into my own personal lettering art and teaching. My "artful lettering" theory revolves around the concept of designing handmade, stylized writing and expressions that extend from an individual's knowledge of basic print and cursive writing.

The foundation of this type of lettering art is built on manipulating simple letters and basic alphabets with assorted art materials and creative design techniques. You have to start with the basics to discover and inspire your direction. Like any new craft, hobby, or activity that you choose to explore, you will best succeed with much practice, consistency, and more practice. Remember, the secret to success in developing your own signature lettering style is "Play, Practice, Write, Repeat!"

THE PENCIL SKETCH

A pencil is always a safe tool, lending confidence to creative endeavors. Write out the words of a favorite quote, using your own handwriting and watch it evolve by following these steps. Can you see how you designed a new font with your very own style?

TIP

Vary the thickness of the letters by tracing close to the pencil letters or farther away from them.

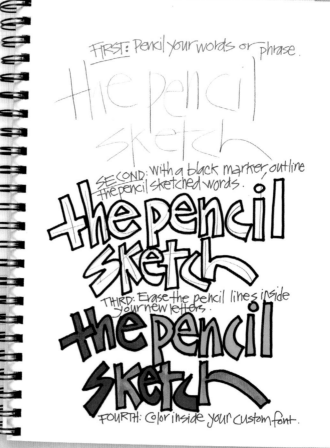

FIRST: Pencil your words or phrase.

the pencil sketch

SECOND: With a black marker, outline the pencil sketched words.

the pencil sketch

THIRD: Erase the pencil lines inside your new letters.

the pencil sketch

FOURTH: Color inside your custom font.

PUMP IT UP

Starting with your own style of lettering, write out some words, then creatively thicken the letters, adding weight to the letter shape to create a completely new style. Use this technique to make your own "pumped up" alphabet.

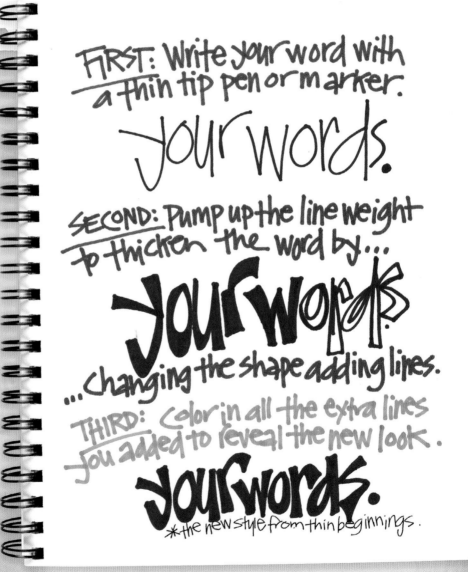

FIRST: Write your word with a thin tip pen or marker.

your words.

SECOND: Pump up the line weight to thicken the word by...

yourwords.

...changing the shape adding lines.

THIRD: Color in all the extra lines you added to reveal the new look.

yourwords.

*the new style from thin beginnings.

MY FAVORITE WHIMSY GRIDS

Get off the straight and narrow by creating pages of wavy repeating lines to use as decorative lettering guides.

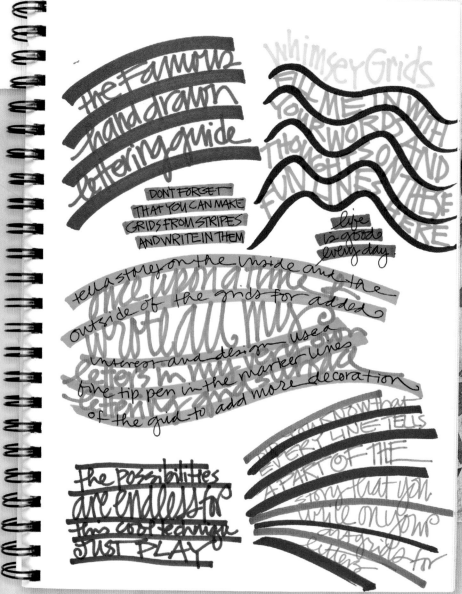

STEP BY STEP

1. Draw "stacked" freeform horizontal lines on a page.

2. Try varying the shapes and dips in your stacked lines.

3. Vary the heights of each line, creating tall and short spaces for handwritten text.

4. Write your phrase or words on each line, creating a fun composition.

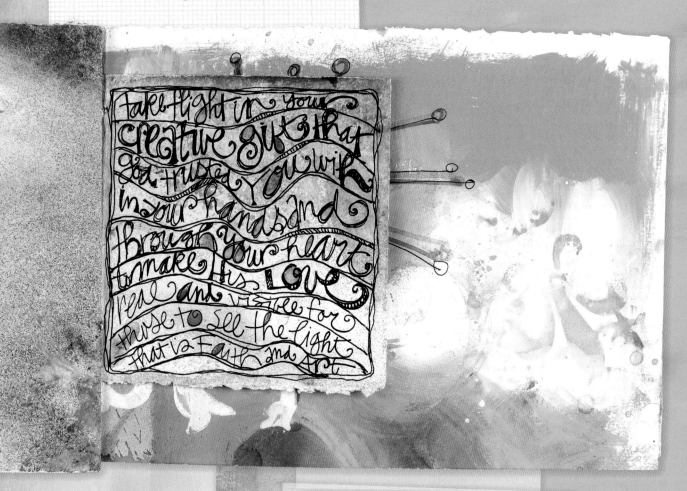

Give movement to the message on a journal page by loosely writing words on a wavy grid.

LETTERS IN THE ROUND

Use a good old-fashioned compass or stencil to make concentric circles that create spaces for words and lettering.

STEP BY STEP

1 Make concentric circles with a compass to create a round grid for lettering and words.

2 Add a phrase or quote by writing around the inside of the circles.

3 Fill in the negative space around the letters for added interest.

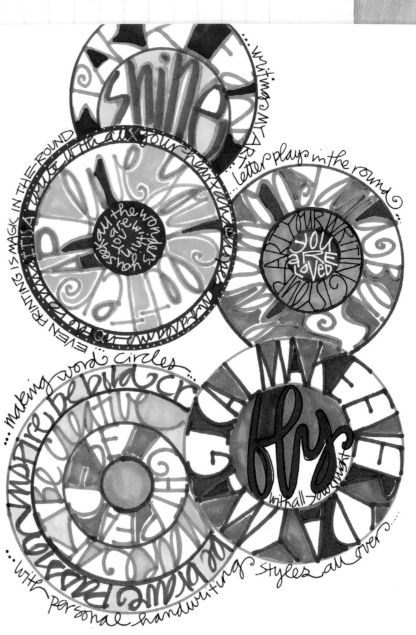

the art of whimsical lettering

GRAPH-PAPER PLAY

Use graph-paper pages to practice altering the heights and widths of letters.

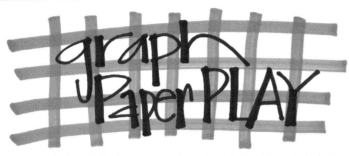

graph
Paper PLAY

Play With Sizes
• TEENY TINY
• BOLDNESS
• INTEREST

PLAY WITH SIZING ON GRAPH PAPER
... even WORK WITH ASSORTED PENS

... it's a lettering guide
It's a good way to train
your your brain remembers...
MUSCLE MEMORY
* remembering perfect sizes

imagine IMAGINE
IMAGINE I Imagine
imagine IMAGINE imagine
imagine imagine imagine

STEP BY STEP

1 Use the blocks or squares on graph-paper grids to design alphabets with consistent design elements and pattern.

2 Vary the height and width of alphabets by counting out assorted patterns using the graph squares as a measurement.

3 Practice size variation and composition on the grids to gain confidence in your freehand attempts.

WORD AND PATTERN

Create a whimsical word box by adding lines and patterns around letters that are composed in a geometric shape.

TIP

In addition to plain black and white, you can add colorful marker work to the spaces.

words and PATTERN Play

1. START WITH A RECTANGLE SHAPE, FREE HAND AS YOUR "LETTERING BOX".

2. ADD A PHRASE, IN PRINTED CAPITAL LETTERS. make sure the letters touch the top and bottom of the BOX as shown.
... with a fine tip pen/marker.

DO WHAT YOU LOVE

3. ADD WEIGHT TO SOME OF THE LETTERS, AND FILL IN THE NEGATIVE SPACES CREATED WITH SIMPLE REPEATING LINES.

words, line and pattern create a visual feast and challenge for the viewer.

WHITE ON SWIPES

Experience the drama of white ink lettering on colorful shapes made with heavy marker or paint strokes.

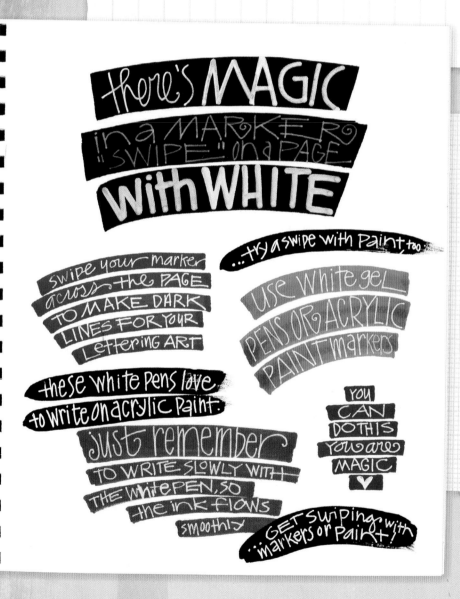

there's MAGIC in a MARKER "SWIPE" on a PAGE with WHITE

swipe your marker across the PAGE TO MAKE DARK LINES FOR YOUR Lettering ART

...try a swipe with paint too

Use White gel PENS OR ACRYLIC PAINT markers

these white pens love to write on acrylic paint.

just remember TO WRITE SLOWLY WITH THE WHITE PEN, SO the ink flows smoothly

YOU CAN DO THIS You are MAGIC

GET swiping with markers or Paint!

STEP BY STEP

1 Make big, fat horizontal marker swipes to create thick lines on a page. An alcohol ink marker works best for this.

2 Use black or dark-colored markers to make the "swish" stroke for the lettering background.

3 Letter words and quotes with white ink pens (I like the Uniball Signo UM-153).

STORY STRIPS

Tell a word story with a quote or phrase by creating text on strips and shapes of torn or cut paper, then adhering them to another paper or canvas surface.

STEP BY STEP

1 Use painted or spray-stenciled background papers for lettering surfaces.

2 Tear the pages into 1" (2.5 cm) strips to be used horizontally.

3 Find a favorite quote or phrase to illustrate, lettering the words on the strips.

4 Arrange a pleasing composition and paste the strips on a journal page to showcase your lettered message.

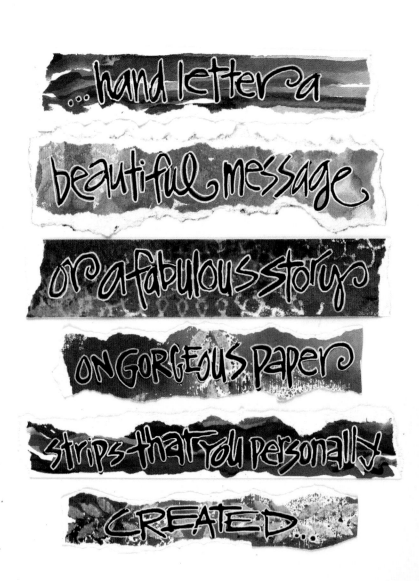

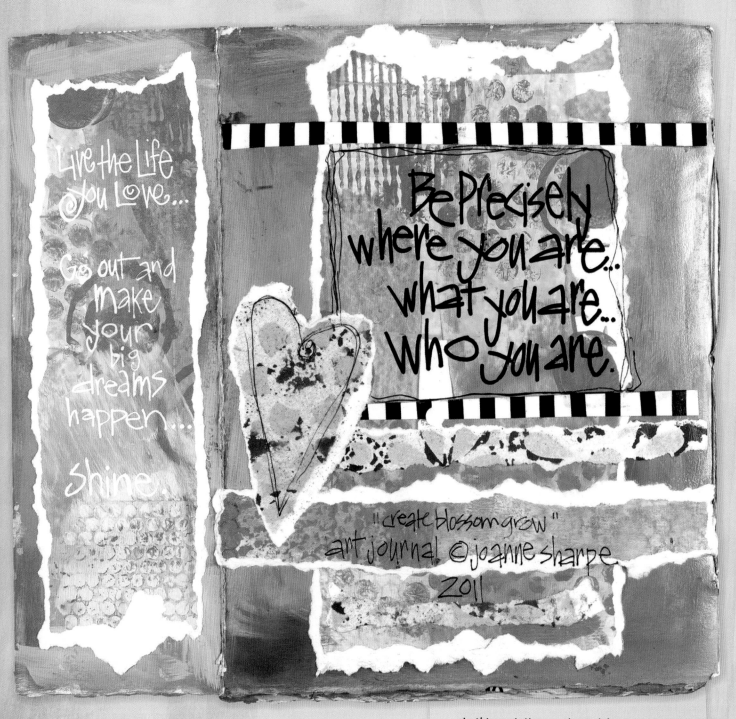

Live the Life you Love...

Go out and make your big dreams happen...

Shine.

Be Precisely where you are... what you are... who you are.

"create blossom grow"
art journal © joanne sharpe
2011

In this variation on story strips, I pasted strips of paper in different sizes and shapes onto a journal page before adding lettering.

FINE LINES, ARTFULLY DESIGNED

Change the expected appearance of letterforms and words by re-creating the shapes and adding interesting design elements.

STEP BY STEP

1 With a pencil, sketch the words first and then begin to elaborate the letterforms.

2 Add a creative and consistent art element (I used a heart shape in this sample) to each letter that unifies the look.

3 Commit to the designs and letters by using a black permanent pen to go over your designs.

DECORATIVE DETAILS

Decorate inside and outside of the letters with doodle patterns and drawings that act like a highlight or embellishment.

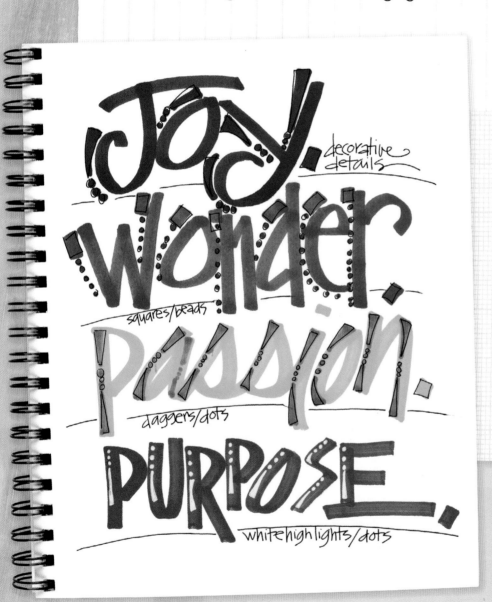

decorative details

squares/beads

daggers/dots

white highlights/dots

STEP BY STEP

1 Make your own stylized, funky letters by adding decorative squiggles, lines with dots, or decorations to one side of the letters in a word or alphabet.

2 Add the drawn doodle elements to imply a highlight or shadow on the outside of an individual letter.

TIP

To be sure each letter is uniform and consistent, always place the added decorations on the same side of every letter.

SKETCHY CHARACTERS

Be loose and free with some "sketchy" writing to illustrate a message or quote.

STEP BY STEP

1 Write out the words in pencil, creating an interesting composition.

2 With a fine-tip black permanent marker, loosely sketch over each letter with several lines. Leaving some white in each letter, fill in some of the negative spaces created by the lines to give the letters weight.

3 Add color around the letters with watercolors or markers.

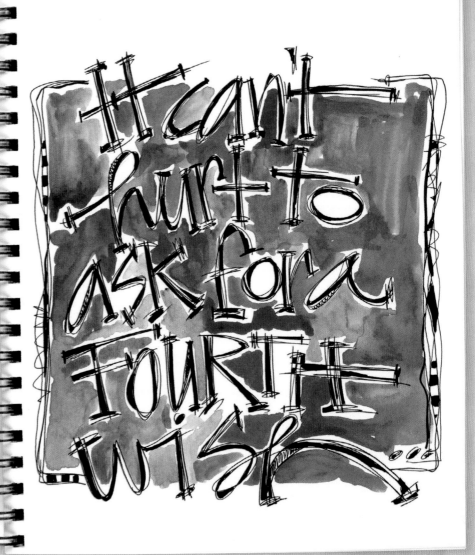

LITTLE BLACK DRESS OUTLINES

The black fine tip outline is my "little black dress" of lettering art. This go-to technique always works to emphasize and ground letters and words on a page.

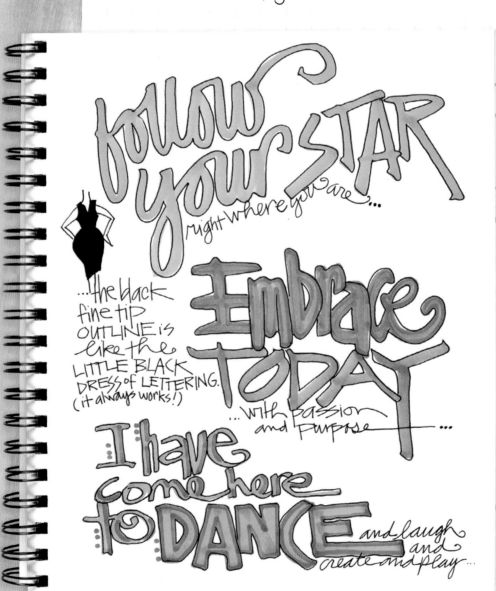

STEP BY STEP

1 Make bold, bright colorful letters with various marker tips. Your handwriting is the art!

2 Outline each letter of each word with a thin-tip black marker or pen, tracing the shape or form exactly.

TIP

Another variation on this style is to try the opposite approach and make bold black letters, then outline them with thin-tip colored pens.

WORD STACKS

Focus on word placement and letter sizes to create dynamic visuals.

STEP BY STEP

1 Vary the sizes and heights of words in a composition when illustrating a quote or phrase.

2 Add drama by exaggerating the size or giving prominence to specific words in the lettered art.

3 Letter a phrase on just the right, left, bottom, or top only of a journal page.

4 Write each word in various heights and widths to stretch horizontally and vertically, forming an invisible box shape for the composition.

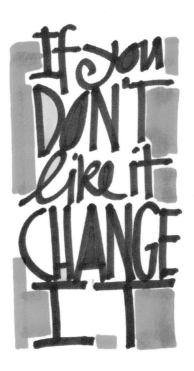

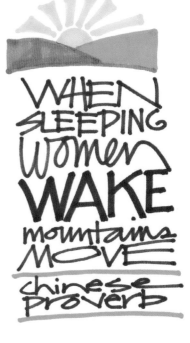

PAINTBRUSH PEN

Think outside the lettering box and let a paintbrush become the pen. "Write" with any watercolor paintbrush. I like a round #8 or #10 brush to create an alphabet.

the paint brush is my pen...making thick and thin lines with the tip of the brush pressing down one more ink going down

vary the pressure on the brush to control the letter weight...

CREATIVE
journey
EXPLORE
discover spirit
ADVENTURE
GROW

Add more and less pressure to the brush tip for varied

1 Load the brush with watercolor paint, acrylic paint, acrylic ink, or India ink. Practice making thick and thin lines by adding and releasing pressure as you paint lines across a page.

2 When you are comfortable and confident with the movement of the ink in the brush, start to "paint write" letters as if the paintbrush was a pen or pencil.

3 Try varying the line thickness of letters with heavy and light pressure on the brush, releasing a small or large amount of liquid from the bristles.

4 Be loose and uninhibited when using this very expressive lettering technique. Stretch the lines, heights, and widths of each letter as if it's an individual art element.

MAGIC MARKER SHAPES

Who doesn't love to write, draw, and color with markers? Make whimsical, colorful shapes to fill with words and letters using assorted markers and several techniques. Gather any brand of markers you have. When lettering, I prefer a dual-tip alcohol-based marker that is waterproof and has good color integrity, such as Copic, Prismacolor, or Faber-Castell.

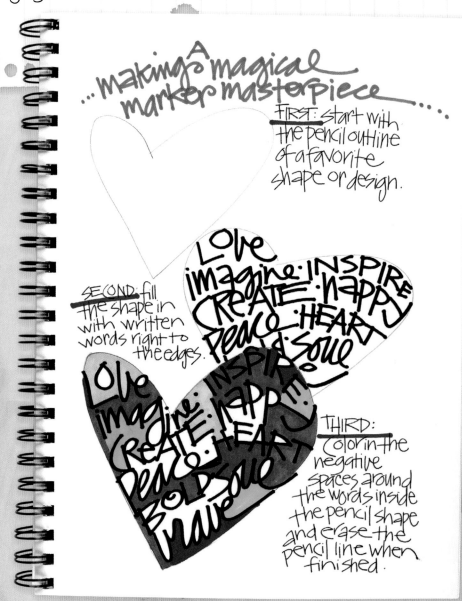

...making a magical marker masterpiece....

FIRST: start with the pencil outline of a favorite shape or design.

SECOND: fill the shape in with written words right to the edges.

THIRD: color in the negative spaces around the words inside the pencil shape and erase the pencil line when finished.

INKY GOODNESS

Experiment with unusual tools and assorted inks to create authentic hand-drawn letters.

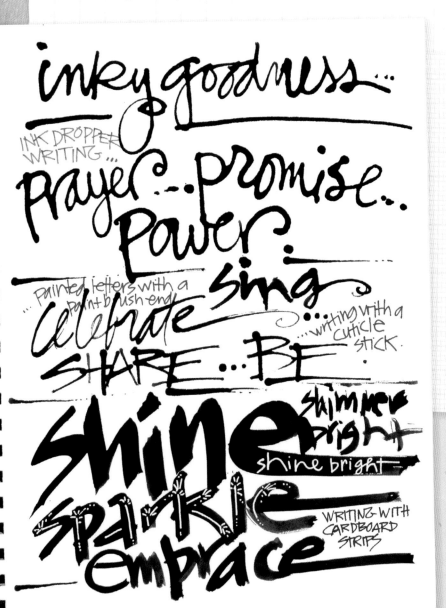

inky goodness...

INK DROPPER WRITING...

Prayer...Promise...

Power...

...painted letters with a paintbrush end...

sing

Celebrate

...writing with a cuticle stick.

SHARE...BE

shine

shimmer bright

shine bright

sparkle

embrace

WRITING WITH CARDBOARD STRIPS

STEP BY STEP

1 Load an eyedropper with ink and squeeze out the liquid as you write words with the tip.

2 Use the end of a paintbrush, a wooden kabob skewer, or a cuticle stick dipped in India or acrylic ink to write out a phrase or inspirational message.

3 Use cut-up pieces of cardboard dipped in inks to create freeform letters.

BLING IT, BABY

Experiment with adding sparkle and shine to your hand-drawn fonts.

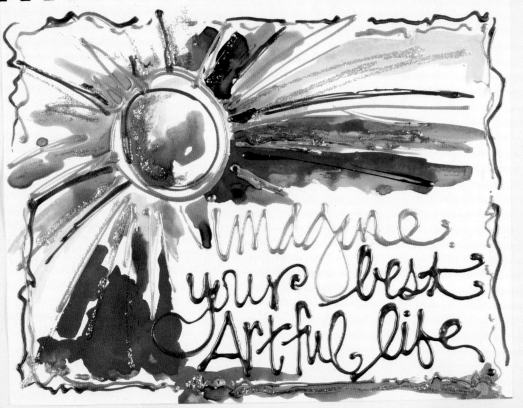

imagine.
your best
Artful life

STEP BY STEP

1 Use dimensional glaze pens to letter words in
 a journal or on a scrapbook page.

2 Add shiny glitter highlights to letters and
 artwork using the many glitter glues that are
 on the market.

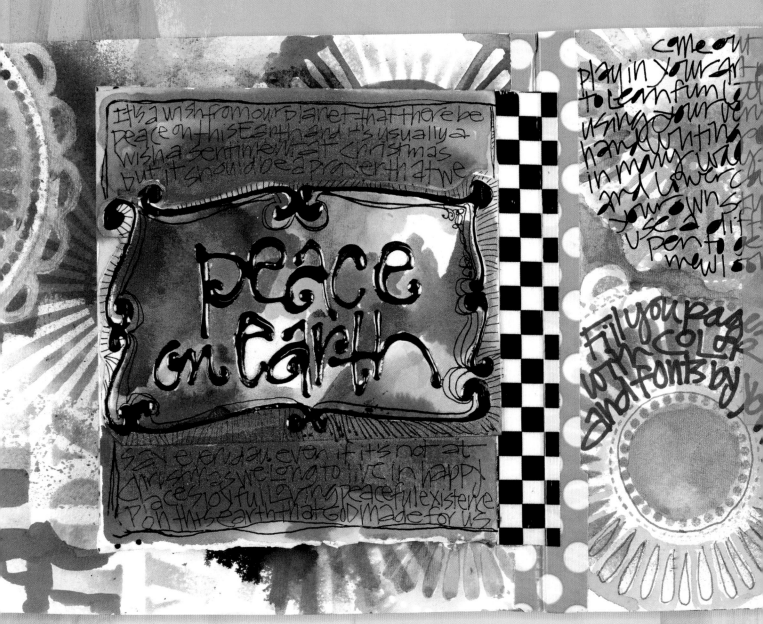

Dimensional paint pens create raised lettering that pops off a page.

HAND LETTERED, HAND CUT

Play with the organic, freeform look of a hand-cut stencil made in your own lettering style.

Use the scraps left behind from your handmade stencils, or the stencils themselves, as collage elements in other artwork.

TIP

You could also arrange the cut-out letters on a page and spray around them. The paper letters will act like a mask and preserve the white of the paper.

STEP BY STEP

1 Use cardstock, Mylar, or any heavy paper for your stencil.

2 Design your words or letters with a marker or pencil on the surface. Carefully cut out the shapes with scissors or a craft knife to reveal the image.

3 Use spray inks or paints to stencil your words on any artwork or journal pages.

PAPER WORD EMBELLIES

Make hand-cut letters and word embellishments from your own color-ful painted papers. These are much more personal and one of a kind when using preprinted papers. Master this process and you'll never have to buy another commercial embellishment again!

STEP BY STEP

1 Make some colorful background papers with stencils, inks, or paints on cardstock paper.

2 With a pencil, lightly sketch some block or script words on the papers.

3 Cut out the words with scissors or a craft knife to create a dimensional paper embellishment.

4 Add the letters to your journal or scrapbook page with a glue stick or your favorite adhesive.

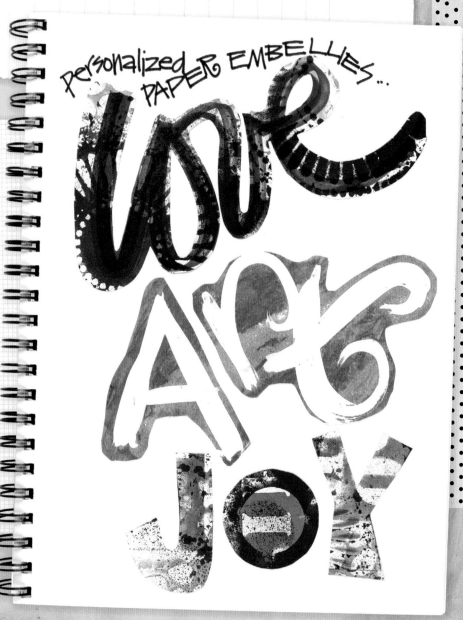

personalized PAPER EMBELLIES... love are joy

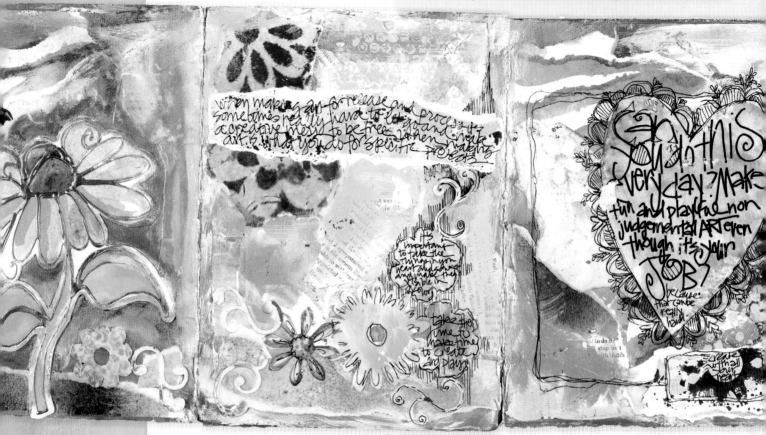

Having explored my go-to art-ful lettering techniques, are you impressed with the incredible artwork that came from your very own beautiful handwriting? Do you have a nice thick journal filled with your practice and learning pages? You can grow with these techniques and elaborate on the concepts to make art that is uniquely yours. Don't be concerned with imitating my samples exactly; be empowered by your own abilities. By being true to yourself, your potential for an exquisite personal lettering style is limitless. Be confident with your own writing as the foundation for stretching and growing artistically.

Embrace the techniques and meth-ods that inspire you!

Be free and loose with your cre-ative lettering, letting it flow from your heart and soul. Embrace your perfectly imperfect artful expres-sions. If you want perfect, flawless, even, smooth, straight letters, you can go print everything out on your computer. Take your time and try all of these techniques and see what speaks to your personal style. Just as you learned handwriting basics as a child, you have now learned the "whimsical lettering basics." You have the power; now make your own lettered magic.

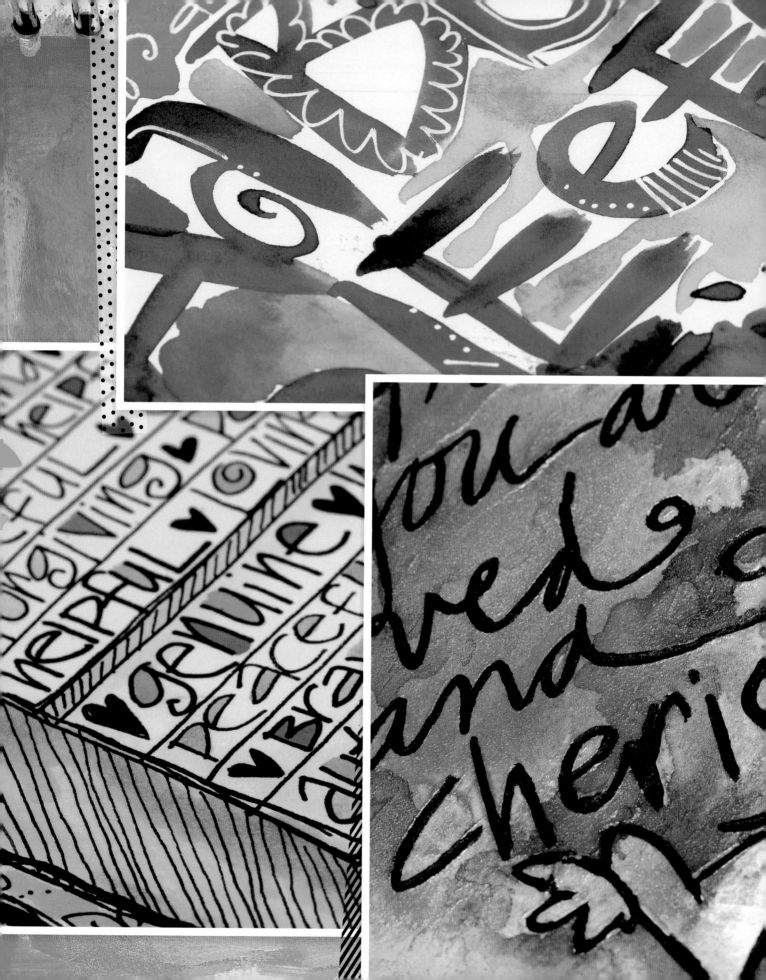

Artistic Alphabets

Throughout this book I've talked about creating lettering art using your own personal handwriting, rather than just copying prescribed fonts. My approach to lettering is based on the idea of transforming a familiar practice with design principles for endless creative possibilities. In this chapter, I'll share fifteen alphabets to illustrate how I create them and to show how you can use them as a starting point for your own artistic alphabets.

MAKING SIGNATURE ALPHABETS

Have you noticed that no one writes anymore? I find nothing more beautiful than putting pen to paper, especially with the freedom to make letters and alphabets however I choose.

Hand lettering restores the human element, creating a social connection that no technology can match. Think about our history that was so dependent on handwritten letters describing life in past eras. Ink on paper, life shared. We wouldn't know much about the past if it weren't for handwritten accounts in letters, ledgers, and journals of days gone by.

In my life and art, I've always been fascinated by the history and evolution of letterforms. These discoveries inspire me to explore new ways of making freehand letters by moving a pen, marker, or brush and implementing traditional characteristics in my contemporary alphabets. Adding interesting lines or vintage decorative elements to alphabets

I used a paintbrush like a pen to loosely letter an entire alphabet in luscious watercolors, then added decorative pen doodles and flooded the negative space with more rich color.

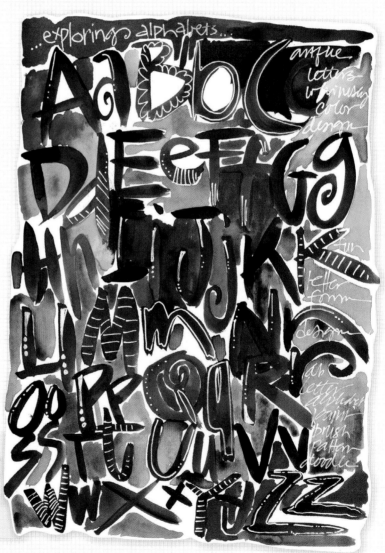

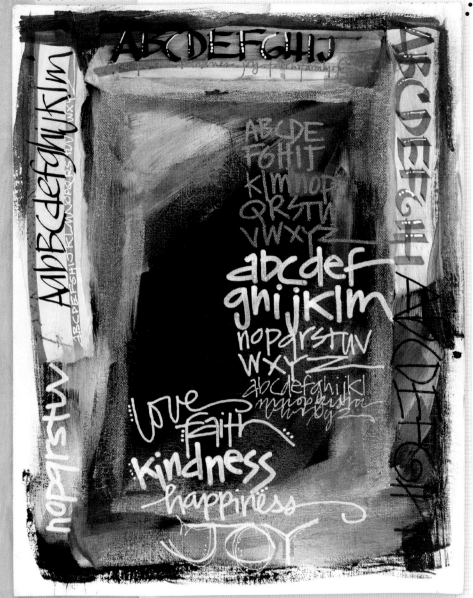

This is a canvas sampler I created to showcase many different alphabet styles.

lection with common elements such as line, shape, pattern, and decoration tying them together.

To make magical alphabets, you must fall in love with your own handwriting. Don't be overly critical of your regular writing, because it's the essential ingredient for this process. If you're not crazy about it, change how you think, knowing that it's just the foundation for letter making as artwork. In my teaching experience, I constantly hear so many people say, "I hate my writing" with the same conviction as they say, "I hate my nose," or any other personal physical characteristic. I'm pretty sure that transforming your handwriting into a personal art expression is a lot less painful than a nose job!

Be free, let it flow, and make it up as you go. Think past the ABCs you learned in elementary school and be adventurous with loose lines and inventive letter shapes. Dare to be perfectly imperfect in discovering your inner font. You know the basics that you've used your entire life, now turn your letters into art by adding, drawing, changing, and inventing elements of basic letters. Do you see how the possibilities are infinite? The more alphabets you invent, the more your signature style will evolve.

makes a dramatic impression for a quote, thought, or message.

As we explore the ideas in creating original art alphabets, know that this chapter is not about making the cutesy stuff. You know, the letters that look like bananas, balloons, and cupcakes, with hearts that dot the letter i. It's about inventing letters for a whole alphabet as a col-

INGREDIENTS FOR CREATING AN ARTISTIC ALPHABET

There are specific ideas that I incorporate into my own hand-drawn alphabets.

Start with your own personal handwriting as the foundation for a new alphabet.

Try new pens, markers, and brushes to transform your ordinary writing and give it a fresh look and unexpected style.

Make sure every letter has a consistent element that unifies it as a member of a collection, such as an inventive line formation or embellishment.

Give the alphabet a name or title.

Aa Bb Cc Dd Ee Ff Gg
letter YOUR ALPHABET with a paint brush LOADED up with
Hh Ii Jj Kk Ll Mm Nn
Juicy watercolor PAINT or ACRYLIC INKS. Use the paint brush
Oo Pp Qq Rr Ss Tt Uu
like it's A PEN or pencil in YOUR HAND forming LETTERS
Vv Ww Xx Yy Zz
... paint out Loud...

Just like the lined paper you used when you were first learning to write, a grid helps keep your letters in line.

MOTHER KNOWS BEST

This would not be a true lettering book without celebrating my own mother's handwriting. Growing up in the shadows of her writing style was a huge inspiration in my love of lettering. It's very rare today to see such perfect letterforms. Educated in Catholic schools in the 1940s, Mom learned handwriting with the strict rules and disciplined teaching style of her era. Penmanship was a daily classroom activity, and students strove for perfection with the highest standards. Mom remembers vividly that J was her favorite letter to write and can recall the emotion attached to forming the letter. My birthday cards are always graced with the most perfect letter "J"!

YOU ARE WHAT YOU LETTER

I have always loved words, art, and talking, and hand lettering has been one of my passions my entire life. My artwork always "speaks" with a colorful illustration and a personally designed alphabet or font appropriate for the message.

My personal "lettering notoriety" started in high school with my campaign for junior class president. Handmade, colorful flyers and posters with bold marker letters and posters saturated the hallways and cafeteria of Our Lady of Mercy High School. My slogan was "Go Wacky, Vote Zawacki." (With a maiden name like Zawacki, what else could I do?) I won the office that year and senior class president the next year. For the past thirty years I've received notes or messages from my former classmates who see my artwork all over the world and say, "I knew it was your writing!" My handwriting paired with whimsical artwork has always identified who I am as an artist and human being. It is artwork that reflects my values and my personality and exposes the depths of who I am as an artist. My lettering is my art.

HEY FRESHMEN!
Residents! Commuters!

here's YOUR CANDIDATE for CLASS PRESIDENT...

Joanne Zawacki°

She's got Charisma, talent, charm, etiquette, personality, brains, dexterity, beauty (beyond repair), humor and............... HUMBLENESS !!

* She has experience !

Joanne was president of her junior and senior class in high school and served as a class representative in student council for four years. She's been involved and know's what it's like to plan fundraisers and social events.

A WILLING LEADER
VOTE ZAWACKI!

Just a few samples of my early lettering efforts.

Senior Retreat
May 2, 3, 1977

ALPHA ART IN ACTION

These fifteen hand-lettered, stylized alphabets originated from my own print or cursive writing. Try the techniques I describe to create your own personalized alphabets, rather than simply copying mine. You'll recognize some of my basic artful lettering techniques from the last chapter and see entire alphabets created with those ideas.

THICK IT

Transform your personal printing style by adding weight to each letter. Use both thick and thin lines to create new letterforms.

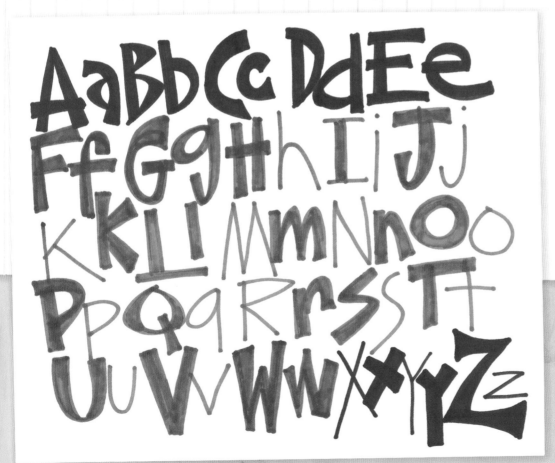

PENCIL PERFECT

Write an alphabet in pencil and then trace around each shape in marker to invent a new letter shape. Erase the pencil lines to reveal a new one-of-a-kind font.

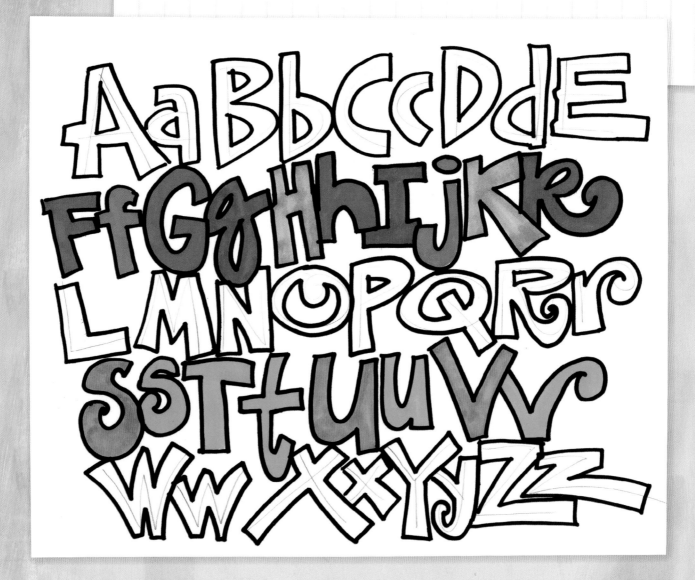

EXTREME CURSIVE

Stretch your handwriting and experiment with extreme slants and loopy versions of your personal cursive writing.

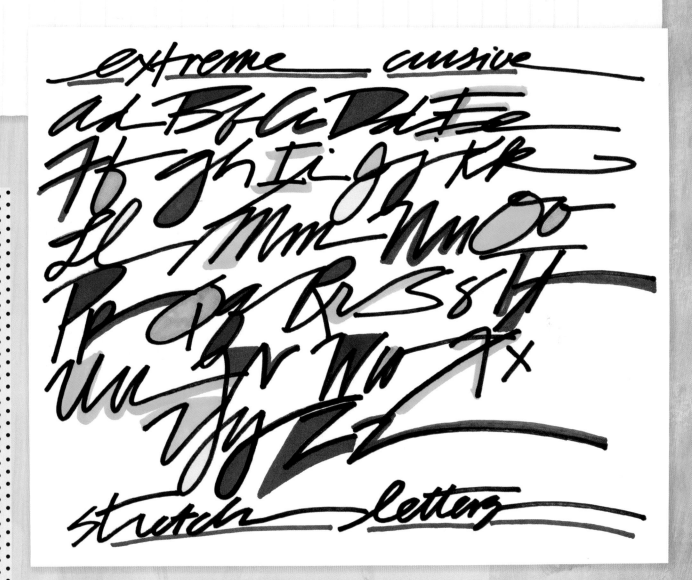

the art of whimsical lettering

THE LETTERING EQUATION

Once you're in the whimsical lettering groove, you'll realize that the possibilities for creating lettering styles are endless. I have developed a system called the "Lettering Equation" to experiment and design different patterns of letters to create unique word art. I'm sure there is an actual mathematical formula that will determine how many ways you can write a single word, but that's all about numbers, and I'm all about the letters.

The Lettering Equation breaks letters down into four variables: uppercase, lower case, print, and cursive. By creating formulas that mix up these variables, you can instantly create artful word design, with, you guessed it, your own handwriting!

THE VARIABLES

Uppercase (**U**)
Lower Case (**L**)
Print (**P**)
Cursive (**C**)

CREATIVE COMBINATIONS

Make patterns for letter placement in words. For example the word "art" can be drawn many ways depending on which variables you place in a sequence.

1	A r T	=	UP LP UP
2	A R T	=	UP UP UP
3	a R t	=	LP UP LP

When you throw in cursive and printed letters, the options become endless.

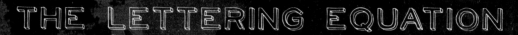

the Lettering Equation...
endless combinations.

pattern = ULULUL
create
U L U L U L

pattern = PCPCPC
create
P C P C P C

pattern = PPCCPP
create

pattern = CCPPCC
create

U = uppercase
L = lower case
P = print
C = cursive

WONKY PRINTING

Make consistent, irregular curls and swirls extending off each letter, giving it movement and personality.

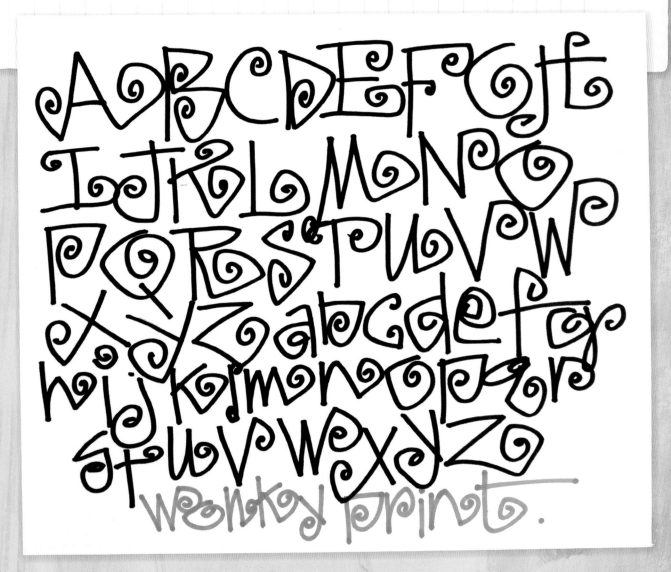

BRUSHING UP

Use assorted paintbrushes (rounds, flats, whatever you have) to letter pages of juicy alphabets with colorful watercolors.

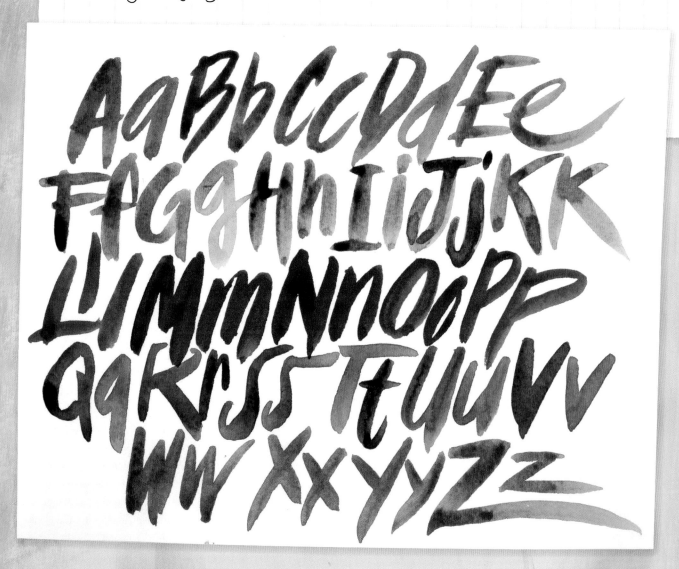

CALLIGRAPHIC CONCEPTS

Use a parallel pen to create a freehand italic calligraphy style.

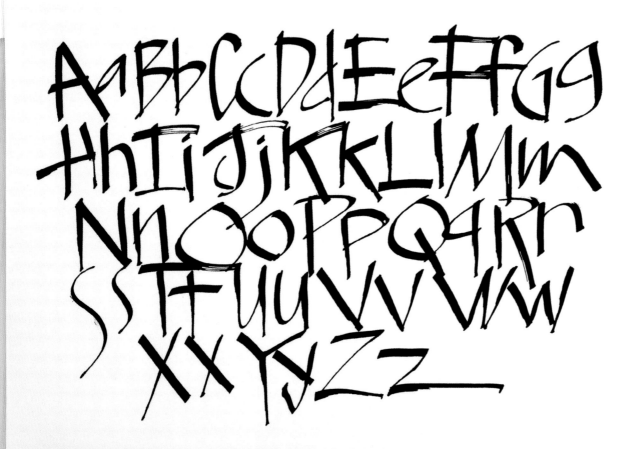

the art of whimsical lettering

IT'S A WRAP

Create whimsical block letters by wrapping a colorful leafy vine around the letterform.

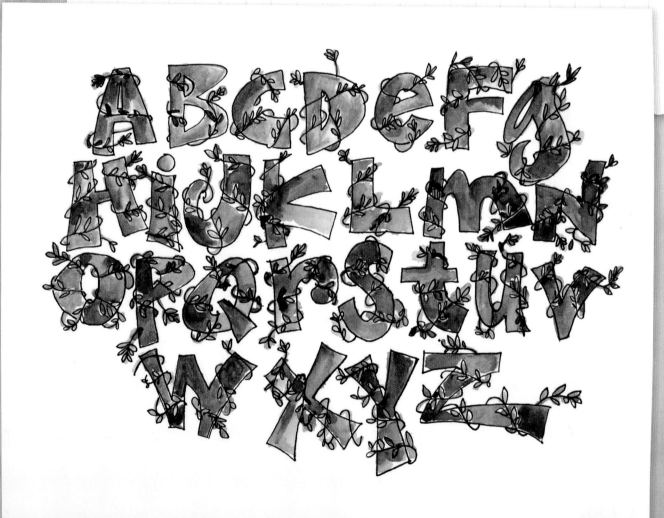

DOODLE DECORATE

Doodle patterns and designs inside block letterforms. Make each letter in the alphabet contain the same decoration or letter each alphabet with mix-and-match patterns to create interest.

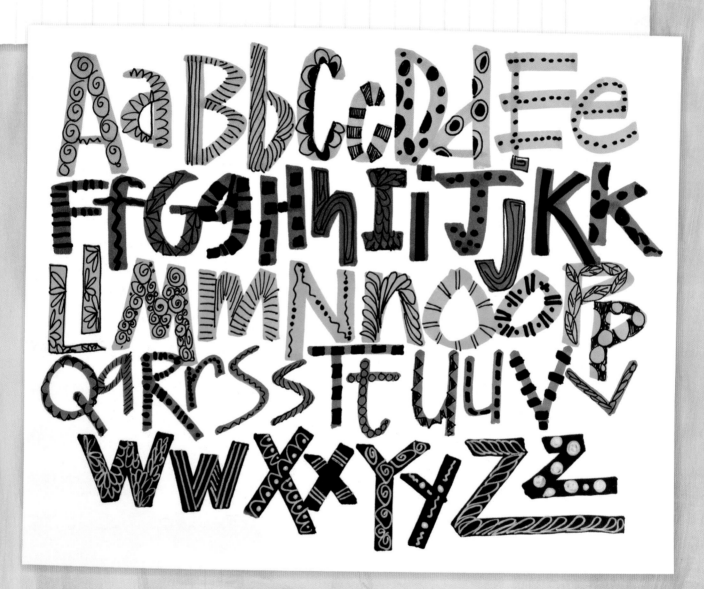

WHAT'S YOUR NUMBER?

You can use the same ideas and style techniques you use in designing letters and whole alphabets to create interesting numbers with an artistic flair. Here are just a few examples to get you started.

...fun with numbers...

POSITIVE NEGATIVES

Be inventive and fill the negative space in and around the letters with casual block shapes and bright color. Watch the letters pop off the page!

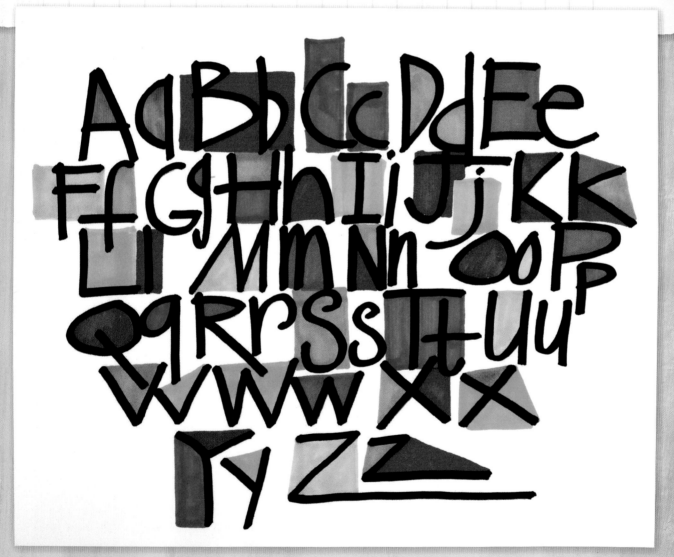

the art of whimsical lettering

DISTRESS ALPHA

Practice pages of alphabets with India or acrylic ink on a dry brush. Use an old brush (one that has seen better days!), ideally with separating bristles, to produce sketchy, distressed-looking lines.

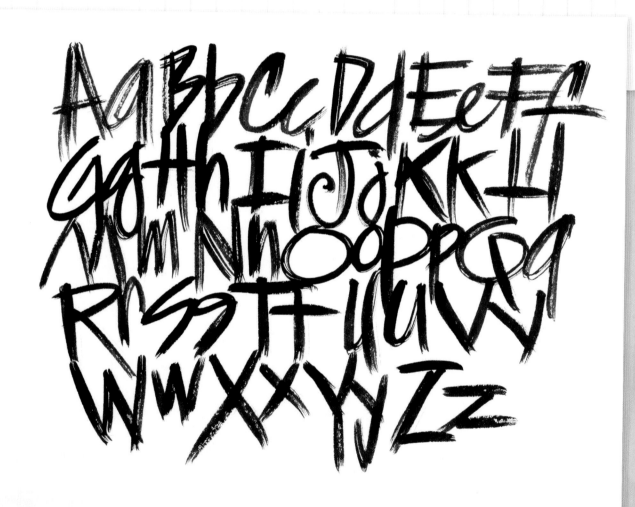

WATER MARKS

Letter an alphabet with a dye-based marker that is not waterproof. My favorite marker for this is the dual brush marker by Tombow. With a water brush, trace over the edges of each letter until the color "bleeds" out, creating a light watercolor wash.

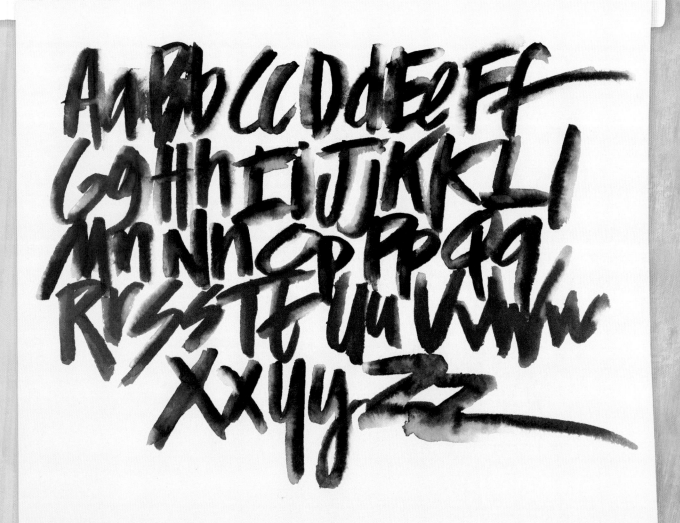

SCRUFF AND SKETCH

Paint an alphabet with watercolor and a scruffy dry brush and let it dry. With a black permanent pen, draw, trace, and loosely sketch around the letters, accentuating the interesting shapes formed by the brush marks.

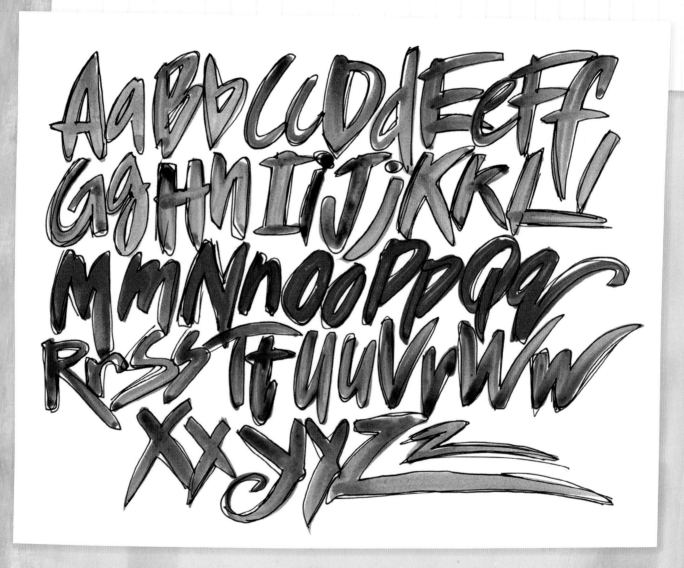

PRETTY EDGY

Create artful, interesting letters by doodling and drawing whimsical decorations and patterns, exaggerating the outline edges of letters.

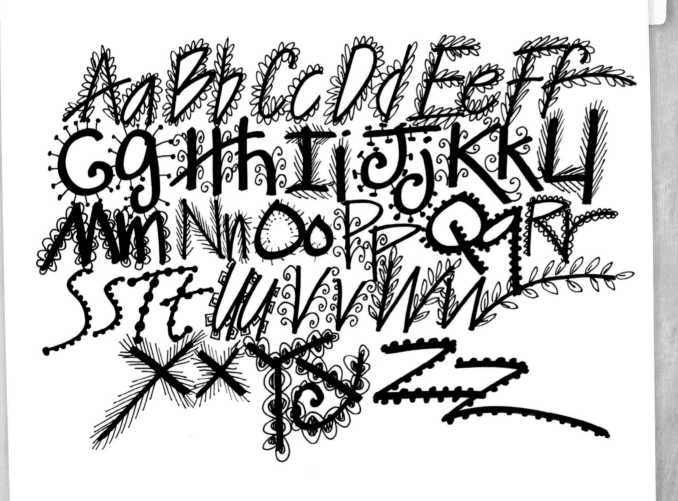

MAKE YOUR MARK

When was the last time you engaged in serious thought about making artful punctuation marks? Stretch your creativity with new design ideas to make marks that stand out while complementing your whimsical lettering.

... creating punctuation...

period

comma

question mark

semicolon

exclamation mark

ampersand

quotation marks

Art and Letters

In this chapter, you'll see lots of samples of my artwork that incorporate whimsical lettering. They illustrate how I implement the techniques discussed in the book into my own personal artwork, whether in my journals or on other surfaces, such as canvas and fabric. I hope you're inspired to try the same techniques in your own creative endeavors!

FROM JOURNAL TO FINISHED ART

I devoted an entire earlier chapter to journals (see The Letter Love Inspiration Journal on page 20), so you know by now that working in journals is my preference when making art daily.

If you were to view my entire artwork portfolio, you'd see that most of my current art and lettering work is done in assorted art journals and bound books. I love the freedom of making page after page of artwork on the crisp, clean, untouched pages of a new journal, with no other intention than to make art. Practicing and experimenting with no particular reason inspires me to play, leading me to significant discoveries and directions for my art. I develop new letters, plan new compositions,

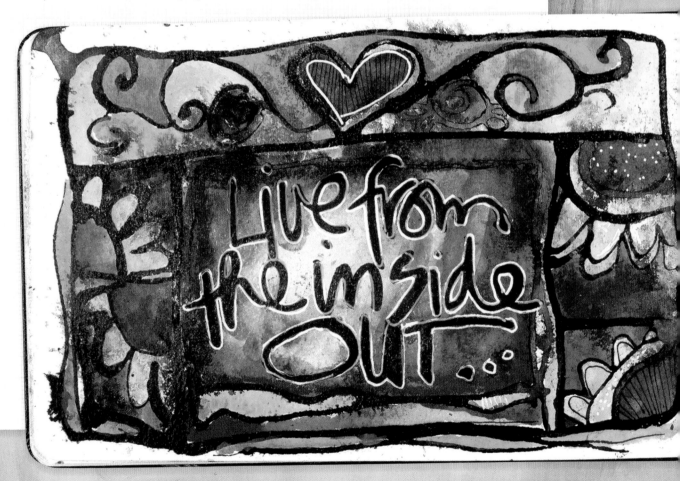

and make mistakes. I can always tear out the page if I really don't like something that's not adding to my creative joy. It's my safe place to learn and use different materials. Using a journal as an art tool also serves as a personal style reference and can be a catalyst for incorporating specific lettering techniques into journals, wall art, gifts, mixed-media pieces, and more.

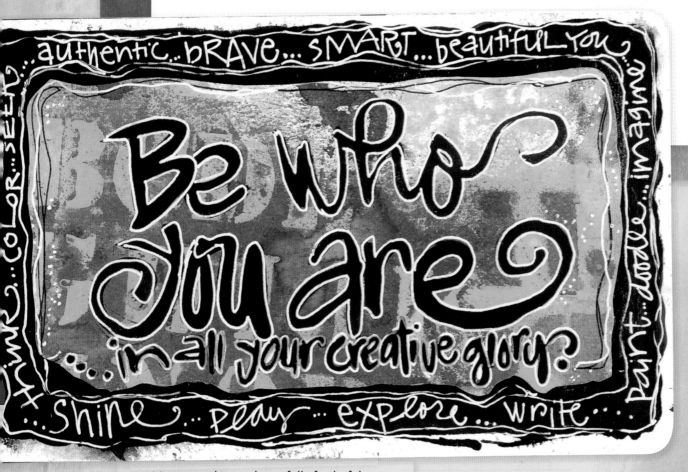

My personal journals are full of colorful experiments with layouts, background treatments, art elements, words, and letterforms.

ARTFULLY ABSTRACTED

Practice freeform, organic lettermaking with loose doodle drawing to create an abstracted image. Use fine-tip pens and colored markers to letter, exaggerating shapes and adding decorative lines and patterns.

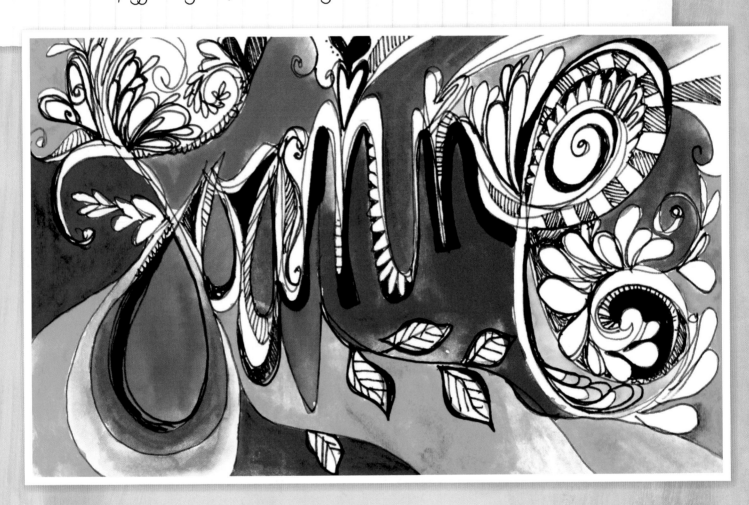

WORD STACK

On a colorful mixed-media background, I "stacked" the lettered words to create a strong vertical composition. I also varied the width and height of the words and added patterns over the letters for extra interest.

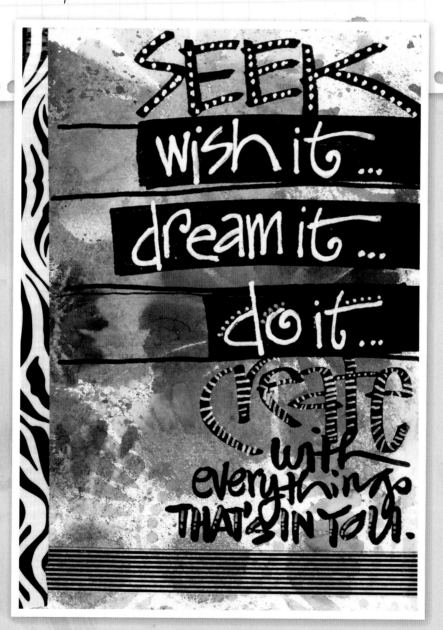

WATERCOLOR WHIMSIES

Colorful watercolor and inked backgrounds create a surface for showcasing poetic words.

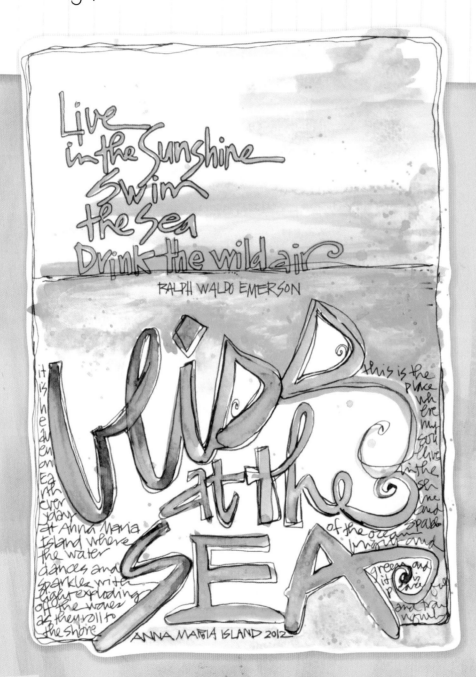

the art of whimsical lettering

FEARLESS FRISKET

Make your own lettering "masks" with frisket. Frisket is a latex masking fluid used mainly by watercolor artists to block out certain areas in their artwork. For lettering art, use an inexpensive brush with frisket to paint large words and let it dry completely. Add a watercolor wash over the entire surface and let that dry completely. With a soft cloth, gently peel away the frisket to reveal the dramatic lettering under the watercolor. Add journaling with a white pen over the watercolored areas.

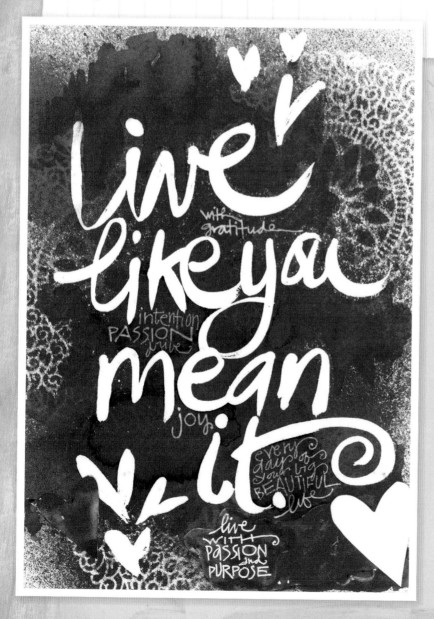

GESSO ETCHING

Apply molding paste or gesso with a palette knife to heavy paper or canvas. Write words with the pointed end of a paintbrush and then accentuate the letters with black. Add color to the background with watercolor or acrylic paint.

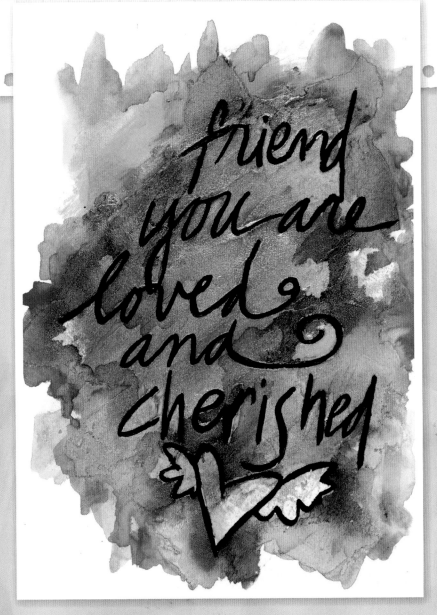

MARKER MASTERPIECE

Use a Tombow water-soluble marker to doodle an illustration on water-color paper. Letter a quote with a black pen so the words stand out in the colorful composition.

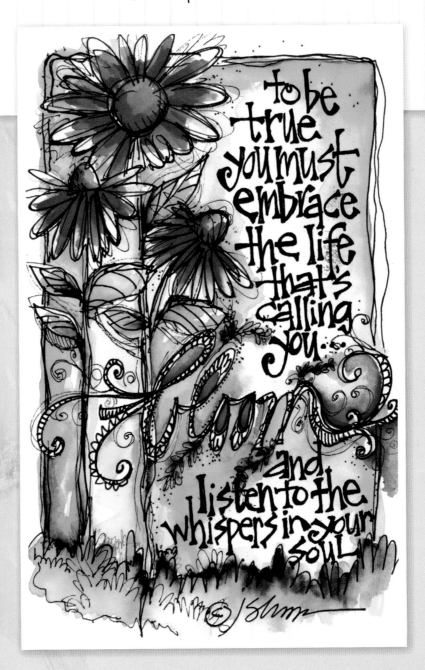

FABRIC AND FONTS

Paint muslin fabric with acrylic paints and letter a message with assorted permanent pens. I added machine stitching around this piece to frame it.

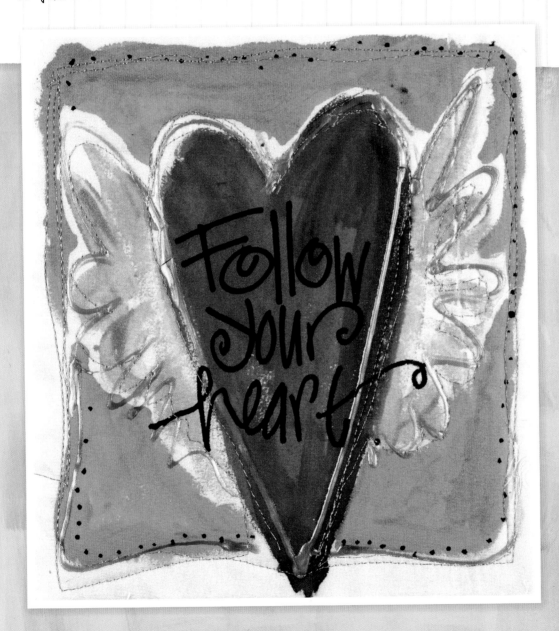

LETTER AND STITCH

Write a verse in pencil or a fine-tip Pitt pen on muslin fabric. Hand-stitch over the written message with colorful embroidery threads.

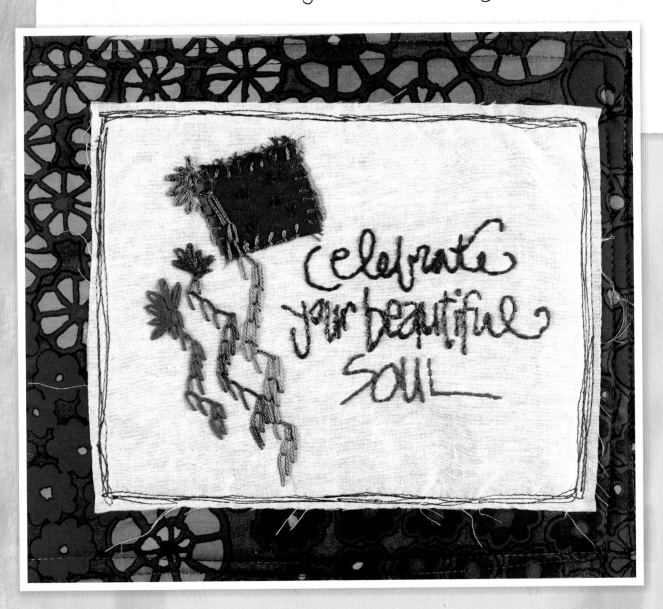

LITTLE ACCORDION BOOK

For a fun alternative to a journal, keep a collection of small written words and phrases in an accordion-style book

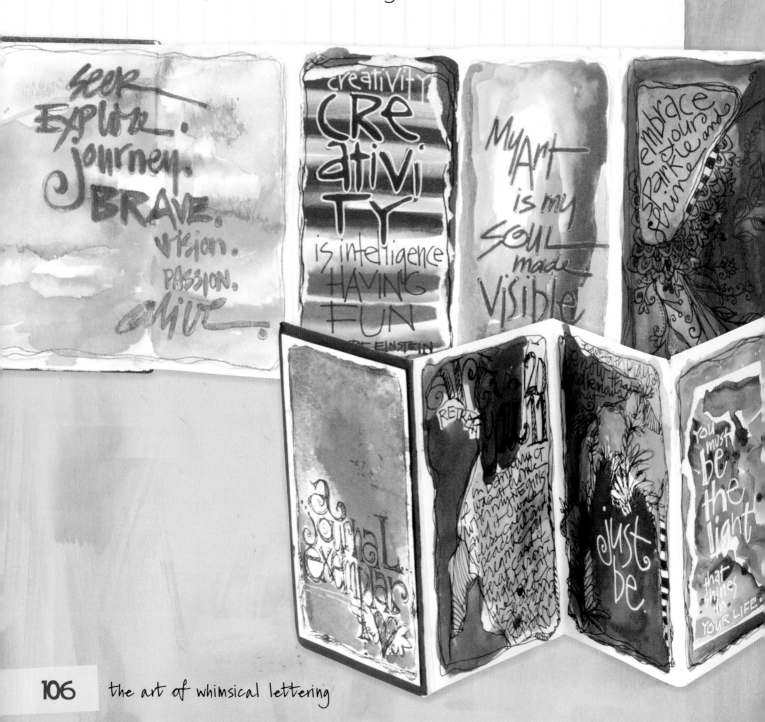

Remember making a paper fan out of looseleaf paper back in grade school? The same concept is used for making an accordion-style art journal. Cut watercolor or Bristol paper into strips at least 3" to 8" (7.5 to 20.5 cm) by 12" to 20" (30.5 to 51 cm). Any size strips will work, but you want to have large-enough pages to paint and letter. Fold the paper in half and then fold the sections back and forth using the paper-fan technique. Paint and letter each individual page on both sides.

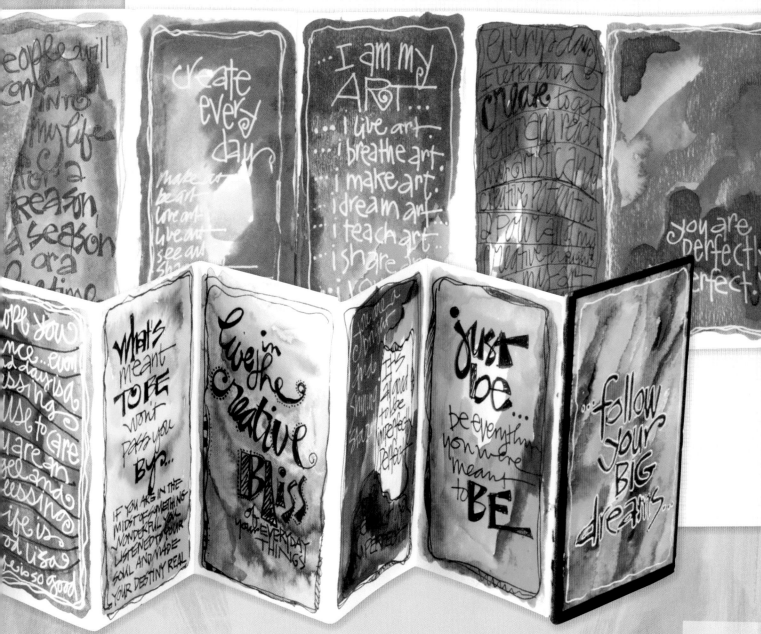

TEENY TEXT

Write one large word and then fill in the interesting spaces around it with tiny lettering.

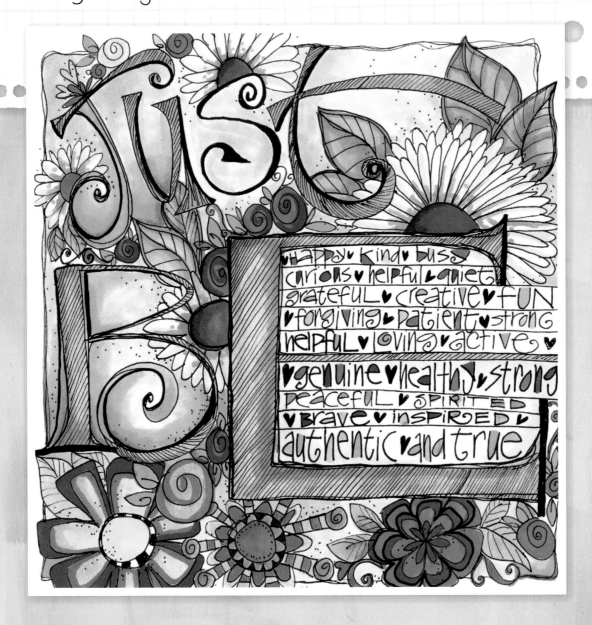

ARTFUL COLLAGE

Color assorted papers with spray inks, then tear them into strips. Add favorite words and phrases on the papers and paste them on journal pages, textured cardboard, or any heavy paper background.

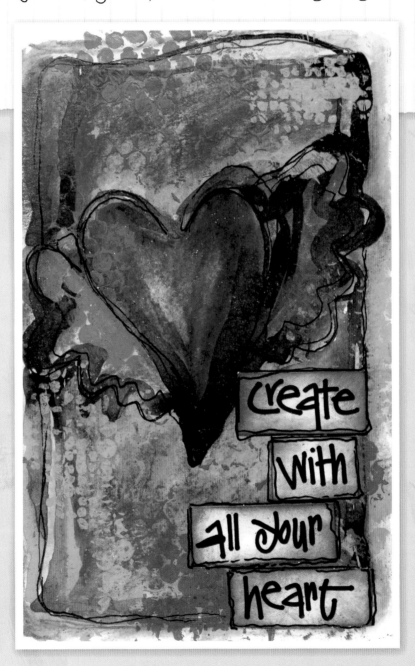

create
with
all your
heart

CANVAS ART

Paint a canvas with acrylic paint and add lettering with permanent pens or acrylic paint markers.

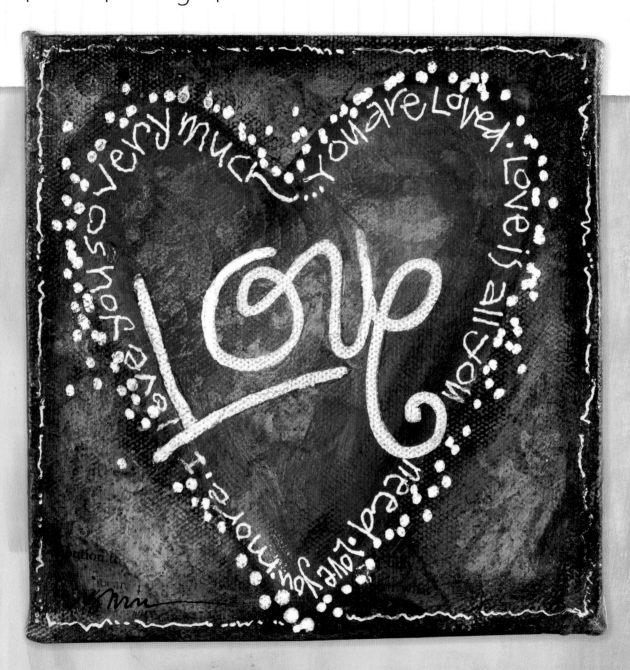

TISSUE-PAPER TEXT

If you panic at the thought of adding hand lettering on your beautiful artwork, try my tissue-paper trick

Write out your words or phrases several times on white tissue paper (plain gift-wrap brands are fine) using waterproof pens or acrylic ink until you are satisfied with the lettering. Cut out around the letters in a freeform shape, and attach them to your artwork with a "gel medium sandwich." Apply a thin coat of gel medium to your artwork, place the tissue on that layer, then add another thin coat of gel medium on top of the tissue. Gel medium will dry clean and clear and blend into the artwork underneath.

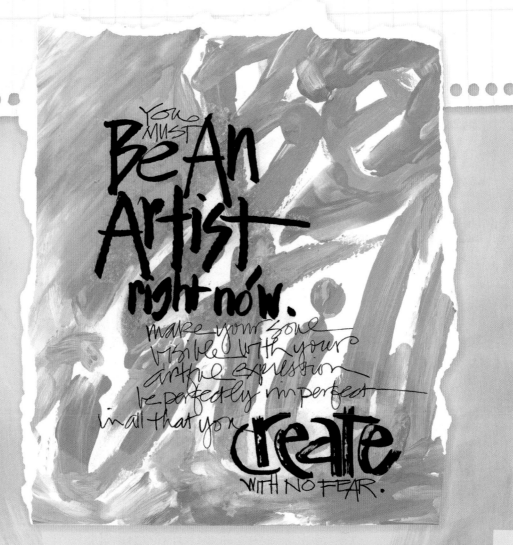

COLOR BOOKS

Construct homemade journals with colorful painted and stenciled art papers. Fold the pages into a book and add your handwritten thoughts and inspirations. Use broad-tip markers for lettering over busy patterns.

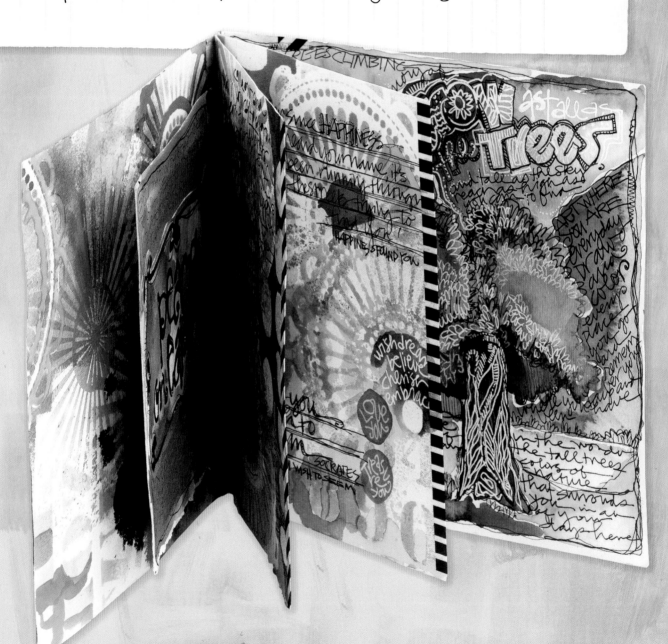

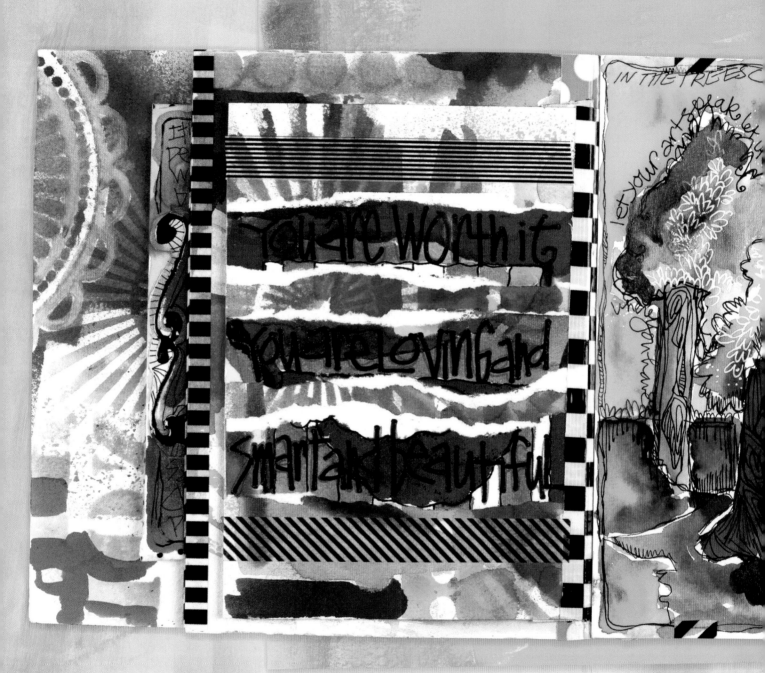

ARTFUL WORD PLAY

Illustrate words in assorted font sizes and colors. Use continuous free-flowing handwriting as a border or background filler pattern.

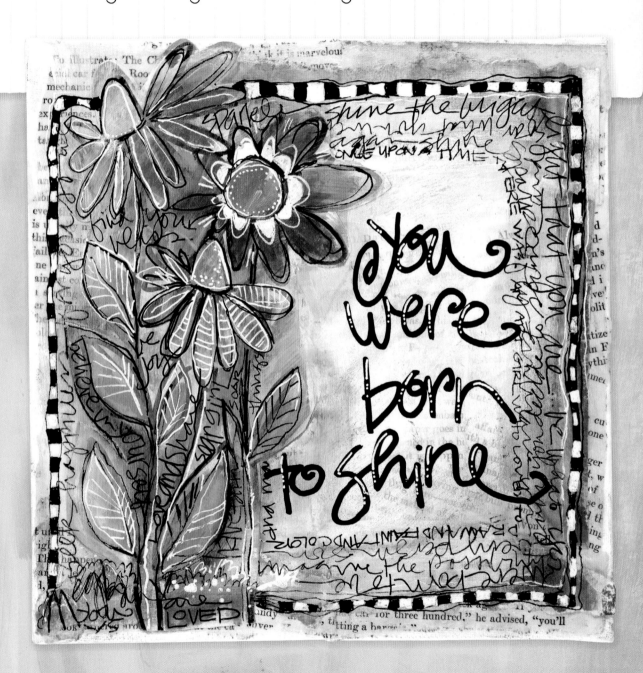

DOODLE-LETTER COLOR POP

Doodle words in black and white. Fill in the negative space around the phrase with bright watercolors, frame it with a loose line, and use writing as a border element.

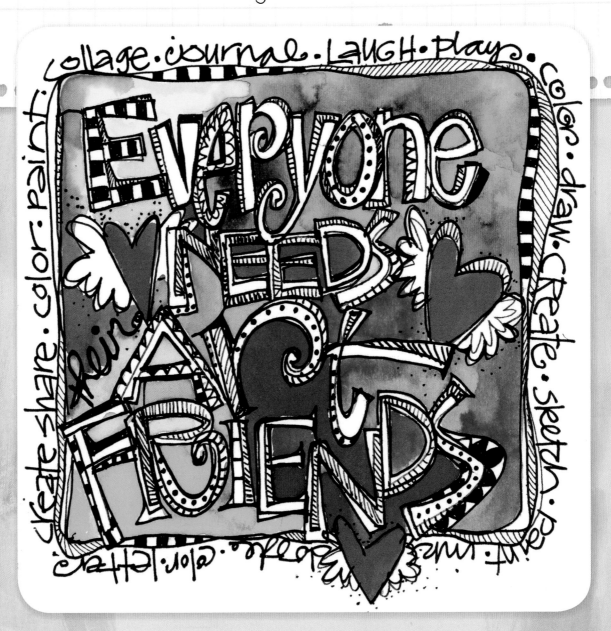

BEAUTIFUL BACKGROUNDS

One of the most enjoyable practices in mixed-media lettering art is making fun and funky backgrounds for words and quotes on journal pages or other surfaces. Anything goes in creating background art! There are countless techniques for making backgrounds to showcase lettering art. Here are just a few examples.

FREE AND EASY

I often just use freeform, loose watercolor or acrylic paintbrush strokes to cover an entire page.

TIP

Paint, spray, splatter, doodle, and decorate your pages ahead of time, so backgrounds are ready for lettering when the perfect words and inspiration strike.

PAINTED MASTERPIECES

Simple painted lines, patches of layered color, and stenciled shapes make perfect backgrounds for lettering work.

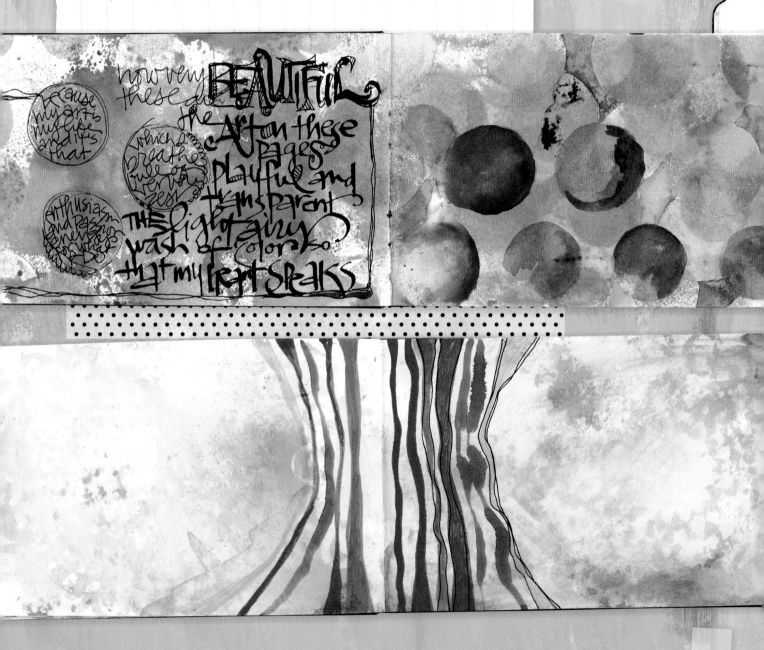

the art of whimsical lettering

TEXTURE TIME

Using spray inks and acrylic paint with stencils, stamps, sponges, and bubble wrap adds interesting dimension and depth on a patterned surface.

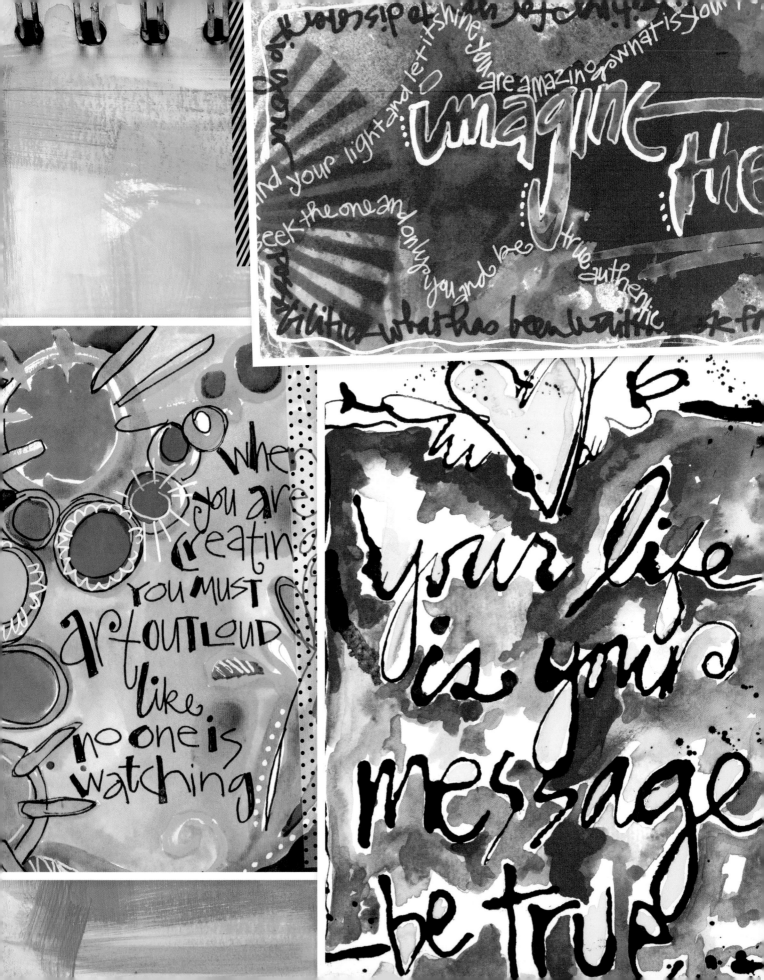

imagine the

find your light and let it shine you are amazing

seek the one and only you and be true authentic

when you are creating you must art out loud like no one is watching

your life is your message be true

Inspired Words & Whimsy

My signature style with whimsical lettering is illustrating quotations and inspirational sayings. Since high school, I have collected thousands of inspirational words and quotes to illustrate in my journals, on paper, or in artwork. I'm energized by words with purpose and by making art with meaning behind it, especially if it touches others. In this chapter, I share some of my favorite quotations and artwork inspired by them.

ART FROM THE HEART

Two of my most treasured pieces of art are those that I created for my parents when I was still in school.

My dad was my biggest cheerleader in life, always encouraging me to be an artist and fly with the wings of talent that I was born with. One of his favorite quotes was, "Happy are those who dream dreams and are ready to pay the price to make them come true." For Father's Day one year, I illustrated that verse for him on a painting. It hung in his office for seventeen years. It's just a simple watercolor with some black ink lettering, but this artwork holds great power over my thoughts and memories, and I see how I have grown up as an artist.

While I'm sharing my early artwork with you, let's embrace the topic of "perfection." Have you ever made a piece of art, completed it, and realized you made a gigantic error? I have: my parent's anniversary gift in 1984. I spent hours painting a perfect watercolor illustration, lettering the words to "Through The Years"

by Kenny Rogers, their favorite song. Perfection I thought! I was so excited to give it to them. That was

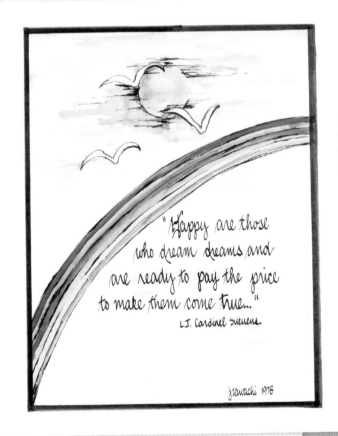

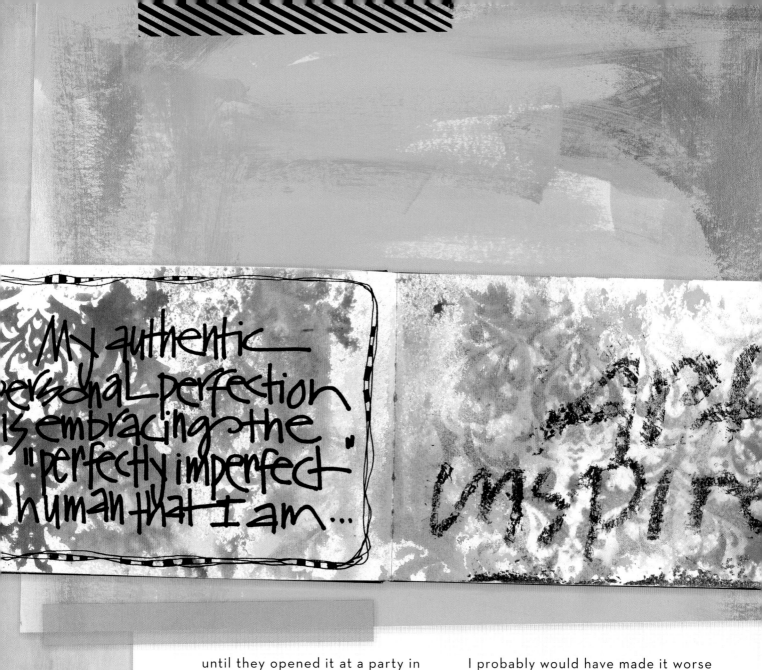

My authentic personal perfection is embracing the "perfectly imperfect human that I am...

until they opened it at a party in front of fifty people. Everyone loved the painting, but then my dad leaned toward me and gingerly whispered, "You forgot a word." WHAT?!!!!!! It was in the *first* line of the fifty hand-lettered lines. I was mortified, but don't think anyone really noticed. This "imperfection" made the most wonderful memory and life lesson for me. I really couldn't "fix" the painting; it was already under glass.

I probably would have made it worse by trying to alter the error anyway.

When I look at this thirty-year-old painting, I see it as a symbol in my own life, knowing that my authentic personal perfection is embracing the "perfectly imperfect" human that I am. And I like it, it's freeing. It's okay to make a mistake, especially when your heart is in the right place.

WHIMSICAL LETTERING ART GALLERY

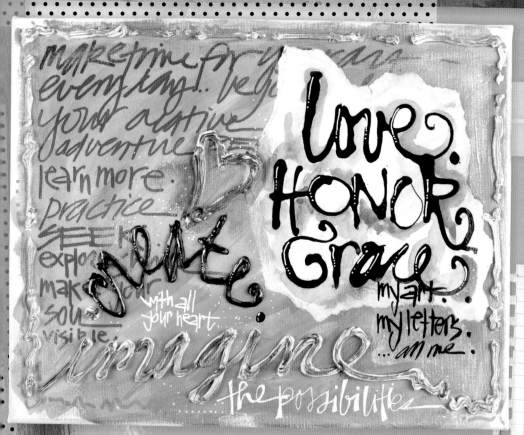

Technique sampler with dimensional paint, acrylic paint markers, assorted pens, and collage elements.

TIP

Words inspire much of the art I create. Start a words journal in which you can collect quotes, messages, and words that move you. I have shelves of sketchbooks and journals filled with scribbled quotes and experimental writing styles for future artworks. Cherish these journals as reference tools that will guide you in creating word art or illustrations for personal enjoyment or sharing with others.

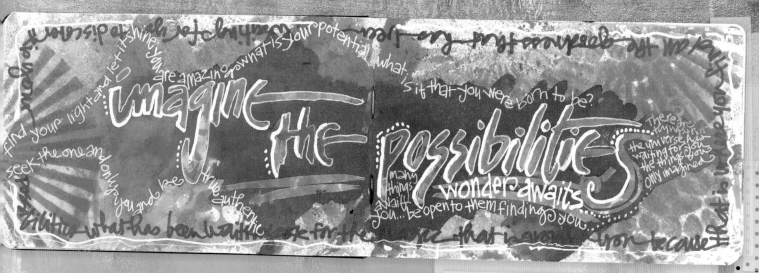

imagine the possibilities

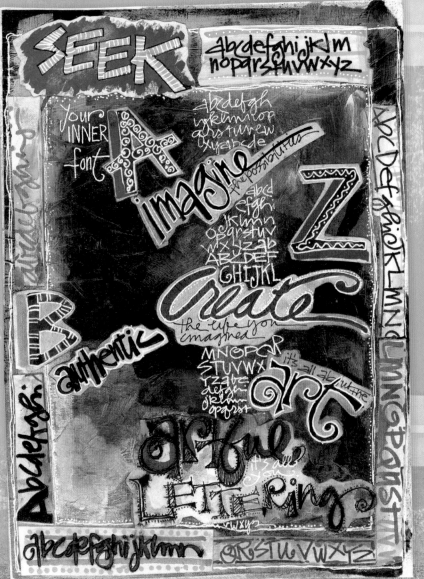

The main message is lettered with frisket, causing it to pop out from a colorful watercolor background.

Mixing up alphabet styles with assorted pens and markers on a black gesso background.

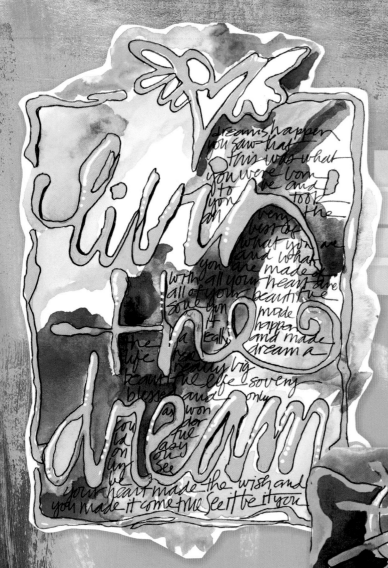

The large lettering was created with watered-down acrylic paint in an eyedropper. The negative spaces were then filled with watercolors, and black Pitt pen writing was added over the watercolor.

Doodle-art painting with Twinkling H2Os mica watercolor and black Pitt pen lettering.

when you are creating you must art outloud like no one is watching

©joanne sharpe 2012

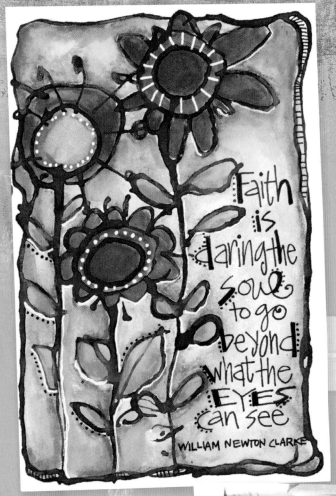

Faith is daring the soul to go beyond what the EYES can see

WILLIAM NEWTON CLARKE

Watercolor and acrylic ink illustration with Micron pen lettering.

Freeform acrylic painted background with white Signo pen and black Pitt pen lettering.

The lettering was drawn with the dropper and Liquitex acrylic ink, and the background was filled with vibrant watercolor painting.

To create this piece, I applied molding paste to heavy paper and "etched" the word love in the wet mixture. Watercolor painted in the negative space surrounding the word highlights it.

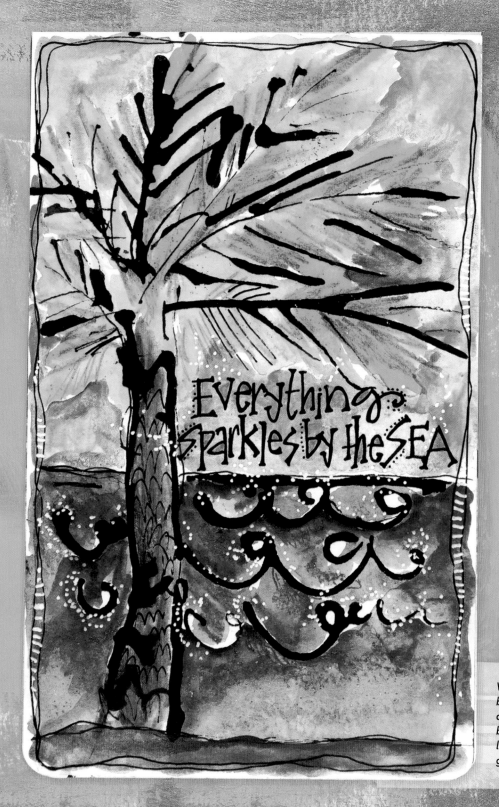

Watercolor-painted background with acrylic-ink details, black Pitt pen lettering, and white gel-pen dots.

THE INSPIRED WORD

I've always collected favorite phrases and quotations. Here is just a very small sampling of my inspired words collection. Use this resource to inspire your artful lettering and word creations. If you ever are at a loss for words to letter, feel free to borrow the phrases from this list.

Love you more.

Reach for the stars, you just might become one.

You are the star for which all evenings wait.

It is what it is.

Whatever you are, be a good one.

Never believe in never.

You get what you give.

All you need is trust and a little pixie dust. —Peter Pan

Live like you mean it.

Today's the day.

Be the change you wish to see in the world. —Gandhi

Love you to the moon and back.

Look for the hidden blessings in every day.

Always kiss me good night.

Pray hard, work hard, trust your gut.

We make a living by what we get . . . we make a life by what we give.

All is well.

Dreams will set free the magic in me.

Every day matters.

If you stumble, make it part of your dance.

Life changes everything.

Change how you see, not how you look.

Don't cry because it's over; smile because it happened. —Dr. Seuss

The cure for anything is salt water: sweat, tears, or the sea.

If you can live your imagination, your life will be a dream come true.

Be kinder than necessary.

Learn from yesterday, live for today, hope for tomorrow.

Never give up.

Dream big.

Embrace today.

Follow your star.

Without faith nothing is possible. With it, nothing is impossible.

It doesn't matter how you look, it's how you see.

You are the only one who can make all your dreams come true.

Faith is daring the soul to go beyond what the eyes can see.

Courage is fear that has said its prayers.

Why worry when you can pray?

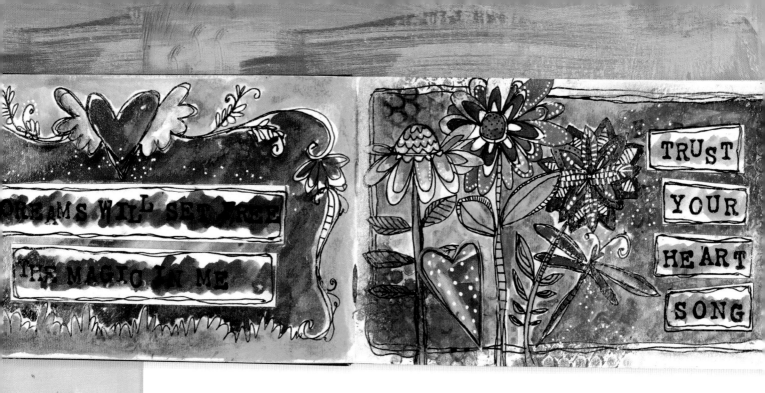

Sorrow looks back, worry looks around, faith looks up.

Faith sees the invisible, feels the intangible, and achieves the impossible.

Surround yourself with people who will only lift you higher.

To have faith is to have wings.

Trust your heart song.

Those who walk with faith always reach their destination.

When you stumble, make it part of your dance.

I have come here to dance.

You can dance, even if only in your heart.

Wish it, dream it, do it.

Sometimes just holding hands is holding on to everything.

Make it a rule of life: never regret and never look back.

Life is a song; love is the music.

Hear the song that lives within you.

Those who wish to sing always have a song.

You are a bright and shining star.

Let your heart guide you; it whispers, listen closely.

Anything can happen when the heart whispers.

Happiness can be painted in any color.

Where there is great love, there are always miracles.

It can't hurt to ask for a fourth wish.

Stand often in the company of dreamers. —Mary Ann Radmacher

I am the designer of my own destiny.

Be everything you were meant to be.

I am here to live out loud.

Life is not measured by the breaths you take, but by the moments that take your breath away.

Yesterday is history, tomorrow is a mystery, and today is a gift . . . which is why we call it the present. —Bill Keane

Faith is seeing light with your heart when all your eyes see is the darkness ahead.

Twinkle, twinkle little star, do you know how loved you are?

As the angels tiptoed from star to star, one of them slipped and here you are.

Believe in your dreams and they may come true . . . believe in yourself and they will come true.

Life is simple; it's just not easy.

Angels make the best friends.

Life is what we make it, always has been, always will be. —Grandma Moses

Life is the sum of all your choices. —Albert Camus

Go the extra mile. It's never crowded.

Even a small star shines in the darkness. —Finnish proverb

Wherever you go, go with all your heart. —Confucius

Everything in life need not be perfect to be perfect.

Live every day with passion and purpose.

Live from the inside out.

Be here, be now.

Everything in the universe is within you.

Close both eyes to see with the other eye. —Rumi

Let the beauty of what you love be what you do. —Rumi

Sing your heart song.

Well-behaved women seldom make history. —Laurel Thatcher Ulrich

When sleeping women wake, mountains move. —Chinese proverb

The joy is in the journey.

Just be.

Live, love, laugh, make art.

Play, practice, write, repeat.

Love big.

Live by faith.

Never ever, ever give up.

You are what you think.

All the wonders you seek are within yourself.

Creativity is a habit.

Be happy no matter what.

Live your dream and share your passion.

If you don't like it, change it.

Let it go.

Do what you love.

Open your heart to new things.

Every day I am blessed.

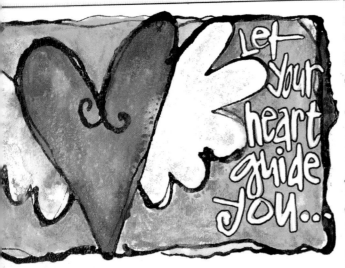

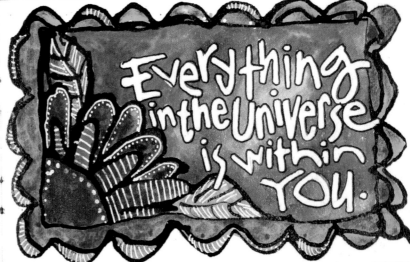

the art of whimsical lettering

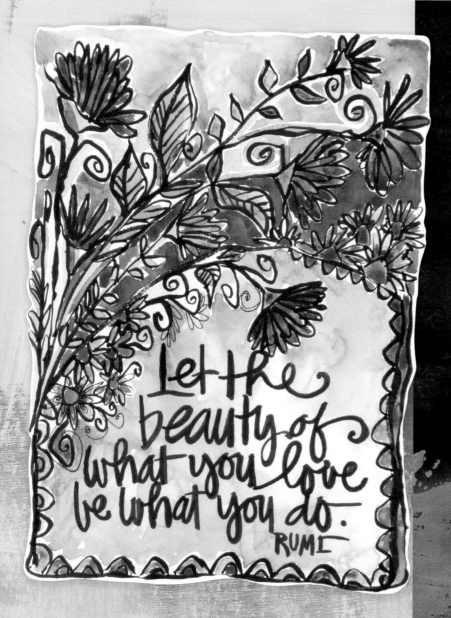

Let the beauty of what you love be what you do. RUMI

MEANINGFUL MANTRAS

Create a mantra using the three words that represent you or your life and letter them in a piece of personal artwork. See my list below if you're at a loss for words.

Joy, wonder, journey, voice, power, inspire, dream, embrace, love, life, laugh, faith, create, believe, trust, imagine, free, potential, brave, become, restore, friend, sweet, kind, matter, enthusiasm, be, vision, promise, share, explore, soul, big, purpose, passion, intention, spirit, destiny, confident, change, power, prayer, see, incredible, heart, prepare, flight, future, choice, beyond, focus, path, seek, see, envision, grow, balance, fly, reflect, speak, share, choice, dare, action, wings, change, happy, hope, whisper, gather, knowledge, simplicity, commitment, goal, gratitude, wish, give, peace, shine, encourage, search, hold, sparkle, glimmer, desire, look, possibility, courage, strength, daring, fearless, bold, sweet.

RESOURCES

COPIC

Imagination International Inc.
PO Box 72149
Eugene, OR 97475
(541) 684-0013
copicmarker.com
Markers

FABER-CASTELL USA INC.

9450 Allen Dr., Ste. B
Cleveland, OH 44125
(800) 311-8684
fabercastell.com
Pens and markers

GOLDEN ARTIST COLORS

188 Bell Rd.
New Berlin, NY 13411
(800) 959-6543
goldenpaints.com
Acrylic paint and mediums

LIQUITEX ARTIST MATERIALS

PO Box 246
Piscataway, NJ 08855
(888) 4-ACRYLIC
liquitex.com
Inks, paints, and mediums

PRISMACOLOR

Newell Rubbermaid Office Products
2707 Butterfield Rd.
Oak Brook, IL 60523
(800) 323-0749
prismacolor.com
Pens and markers

SAKURA OF AMERICA

30780 San Clemente St.
Hayward, CA 94544
(800) 776-6257
sakuraofamerica.com
Pens, markers, and watercolors

SHARPIE

Newell Rubbermaid Office Products
2707 Butterfield Rd.
Oak Brook, IL 60523
(800) 346-3278
sharpie.com
Paint pens and markers

STRATHMORE ARTIST PAPERS

A division of Pacon Corporation
2525 N. Casaloma Dr.
Appleton, WI 54913
strathmoreartist.com
Art journals, sketchbooks, and papers

ACKNOWLEDGMENTS

All my life I have been blessed with an exceptional family and cheering friends who have endured my crazy ideas and believed in me. I am especially grateful to my husband, Tom, for letting me fly, and to my children, Meghan, Matthew, Kevin, and Brian, for schlepping, encouraging, and supporting me, while growing up with their art mom. I am who I am because of my dad, who taught me to visualize ridiculous dreams and inspired in me a tenacious free spirit to make things happen. This I know for sure: big dreams come true for those who see them.

INDEX

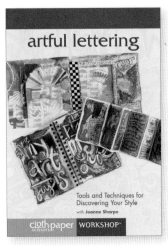

Mount Laurel Library
100 Walt Whitman Avenue
Mount Laurel, NJ 08054-9539
856-234-7319
www.mtlaurel.lib.nj.us